Ansel Adams | New Light
Essays On His Legacy and Legend

Robert Dawson and

Ellen Manchester

David Featherstone

Charles Hagen

Renée Haip

Sandra S. Phillips

John Pultz

Robert Silberman

Colin Westerbeck

UNTITLED 55
The Friends of Photography
San Francisco

Cover image: **Gerry Sharpe,** *Ansel Adams.*
Back cover image: **Cedric Wright,** *The Sermon on the Mount,* ca. 1935.

Staff for *New Light:*
Editor: Michael Read
Editorial assistance: John Breeden, Carrie Mahan and Wendy Richardson
Design and typography: Terril Neely

This book was printed by Gardner Lithograph in the United States of America.
New Light is distributed by the University of New Mexico Press, Albuquerque.

FIRST EDITION
© 1993 by The Friends of Photography
The authors retain copyright in their individual essays.

ISSN 0163-7916; ISBN 0-933286-61-9
Library of Congress Catalog Card No. 92-074384

Acknowledgments

Many people deserve thanks for making this collection of essays and the Ansel Adams Scholars Conference on which it is based a success, but none more than the scholars themselves: David Featherstone, Renée Haip, Charles Hagen, David P. Peeler, Sandra S. Phillips, John Pultz, Amy Rule, John Sexton, Robert Silberman, Jonathan Spaulding, William Turnage, Colin Westberbeck, and Robert Dawson and Ellen Manchester on behalf of the Water in the West Project. Their cooperation and courage in venturing into uncharted waters were fundamental to the creation of a new chapter in Ansel Adams scholarship.

Nearly all the speakers at the conference thanked Amy Rule, archivist of the Center for Creative Photography at the University of Arizona in Tucson, for her guidance and knowledge about Adams materials held there; we would like to add an additional thank you to her for help in identifying and locating scholars of Adams' work. Terrence Pitts, the Center's director, also provided invaluable assistance. At the Ansel Adams Publishing Rights Trust, Pam Feld, Rod Dresser and Andrea Stillman were guiding hands and calm presences in arranging for everything from caterers to reproduction rights.

Virginia Adams, the photographer's widow, was a most gracious hostess during the conference, opening her home to the participants, while John Sexton, a former assistant to Adams, conducted tours of the darkroom. The Hidden Valley Institute in Carmel Valley provided hearty food, accomodations and a central meeting place for the conference. The Coastal Hotel Group and Helmut Horn generously added to the accomodations.

The Ansel Adams Scholars Conference was an added feature of the annual Ansel Adams Workshop, conducted by The Friends of Photography and sponsored by the Eastman Kodak Company, Professional Imaging. Kodak's ongoing support of The Friends' entire workshop program is greatly appreciated. Faculty for the 1992 Ansel Adams Workshop were Morley Baer, Ruth Bernhard, Michael Kenna and John Sexton.

The staff of the Education Department of The Friends deserves recognition for working long and hard to make the conference a success. Margaret Moulton launched the project in 1991; her initial efforts were brought to fruition by Julia Brasheres, Workshop Co-ordinator, Hallie Salky, Workshop Intern, and Deborah Klochko, Director of Education. Thanks as well to their staff of volunteers and assistants, who kept the gears turning smoothly throughout the weekend.

Special thanks goes to all those whose contributions helped this publication come together. Early in the project, Charlie Clarke of Overseas Printing offered valuable technical advice. The illustrations were provided by a variety of sources. J.M. Snowden, sister of Gerry Sharpe, graciously permitted the use of Sharpe's portrait of Ansel Adams reproduced on the cover. Norman Kerr, formerly of Kodak, enabled us to use the images Adams made for the Kodak Colorama. Keith Davis at Hallmark contributed the Harry Callahan images, and Therese Heyman and Drew Johnson of the Oakland Museum provided those by Dorothea Lange. Amy Rule and Dianne Nilsen of the Center for Creative Photography contributed several of the images reproduced with Renée Haip's essay, and Fraenkel Gallery provided the photographs by Carleton Watkins. Vikky Alexander and Ellen Brooks, Anthony Hernandez, Mark Klett, Roger Minnick, John Pfahl and the participants of the Water in the West Project each provided prints of their own work for use in this publication. Above all, thanks goes to Andrea Stillman and the Ansel Adams Publishing Rights Trust for graciously opening its photographic archive to the editor.

Finally, thanks to the team that produced this important book for The Friends: John Breeden, Carrie Mahan and Wendy Richardson, editorial assistance; Debra Lande, marketing consultant; Terril Neely, designer; and David Gardner of Gardner Lithograph, printers. Their efforts have produced an engaging record of an engaging event.

The need for serious consideration and analysis of the life and work of Ansel Adams seems at first implausible. Adams, after all, remains America's (and perhaps the world's) best-known photographer, and eight years after his death his pictures are still the common coin of the art of photography, reproduced endlessly in calendars, appointment books, posters and other indicators of public taste. His output has been assayed in countless coffee-table books, his life laid bare in an autobiography, his voluminous letters published posthumously. Given the omnipresent visibility of his images and the wealth of readily available materials on his life, why do we now want to riddle them for further secrets?

It was with this question that I opened the Ansel Adams Scholars Conference, organized by The Friends of Photography and held July 24—26, 1992, in Carmel Valley, California. One likely answer, I believe, is that the visibility and celebrity of Ansel Adams and his work have largely served to ward off scholarly inquiry into his achievements. For many, Adams' photographs are simply masterpieces, case closed. For others, the mountain of his legacy may seem too steep and forbidding to attempt to scale. Both sentiments are a disservice to his memory, of course; no one more than Adams loved to debate the artistic claims and traditions of his beloved medium. But there remains a glaring disparity between the public adulation of his work and the apparently benign neglect of his career by many of today's active scholars and critics.

The composition of those attending the conference might well have supplied a clue to this disparity. The audience seemed like indisputable evidence of a generation gap in our current understanding of photography as a medium of art. On one side were the friends, associates and business colleagues of Adams, men and women of a generation that took the engaging precepts of "pure" photography as a given. They were balanced by a group of art historians, curators and critics in their twenties, thirties and forties, trained in large part in academic disciplines and taught to interrogate the aesthetic assumptions of Adams' Modernist practice as thoroughly as they might question Gertrude Kasebier's Pictorialist production or Edward Steichen's commercial career.

As Charles Hagen candidly admits at the start of "Beyond Wilderness: Between Esthetics and Politics," he and his peers studying in graduate schools in the early 1970s considered Adams the artist "a bit of a joke," photography's equivalent of Norman Rockwell. As Colin Westerbeck remarks in "Ansel Adams: The Man and the Myth," Adams had become "a mythic figure whose fame eclipsed the very work on which it was based." These are radical and unsettling notions for those who came to photography not many years earlier, when the aesthetic stance that Adams exemplified, argued persuasively for, and finally embodied was so predominant as to seem unbreachable. How was it that one generation's hero could become the next generation's joke? Here, surely, was a subject ripe for discussion.

Any oedipal overtones present at the start of the conference were largely mitigated by the presentations that followed. John Pultz's detailed historical account of the influence that Adams had on Harry Callahan, and on the role that amateur camera clubs played in the formation and distribution of American art photography at mid-century, suggests that the interchange between fine-art and popular conceptions of photography was fundamental to Adams' own conception of his project as an artist. Sandra Phillips' research into the friendship between Adams and Dorothea Lange, and their projects together, discloses an important ambivalence within Adams regarding the social dimension of his aesthetic position—an ambivalence his projects, like *Born Free and Equal* and *This Is the American Earth,* seem intended to dispel. As David Featherstone suggests in his analysis of the latter, a collaboration between Adams and Nancy Newhall, Adams was preoccupied with achieving a balance between a "poetic concept" and social and political efficacy.

Such intriguing and perceptive observations as these offer convincing evidence that the traditional tools of scholarship have much to offer in expanding our understanding of Adams' career. In his essay, Robert Silberman turns to a more obscure and less likely corner of that career—the color pictures that Adams shot for Kodak's Colorama advertisements in Grand Central Station—to uncover the artist's roots in 19th-century notions of the sublime and the "Great Picture." Like Silberman, Renée Haip looks to sources outside the conventional boundaries of artistic practice to reveal the essence of Adams' work; she focuses on the commercial exploitation of the photographer's images of the wilderness to ask whether those images continue to serve the environmental cause they symbolize. Silberman's and Haip's essays are examples of a new contextualist approach to photography history, one in which artistic and non-artistic intentions are considered of equal consequence.

Whether one considers Adams to be at heart a 19th-century Transcendentalist working in the Romantic tradition of the sublime, as Westerbeck and Silberman argue, or as the inventor of a hybrid, socially instrumental form of Modernism, as Featherstone and Haip imply, there is no denying his considerable continuing impact on today's photography. This impact is especially felt in the arena of landscape photography, the genre in which Adams' presence is most clearly manifest. The Water in the West Project, a collaboration of a dozen photographers concerned about the environmental consequences of water usage, provides a compelling example of how the legacy of Adams' environmental concern lives on, albeit in quite different pictorial form. Instead of depicting wilderness as a salve against environmental depredation, these photographers choose to make explicit the tension between the natural beauty of the land and human uses of it.

The testimonies of the Water in the West photographers offer yet another perspective on

Adams' heritage, one shaped by the dictates of practice rather than by scholarship and criticism. What the photographers say, however, closely mirrors the conclusions of Charles Hagen at the end of this volume: "In the end, our attitudes toward the land are as important in shaping it as are forest fires, earthquakes, or erosion. And photographs of the land play an important part in determining and reflecting those attitudes." It should not be surprising that these attitudes have shifted considerably since Adams took his most stirring photographs; nonetheless, he continues to be admired and even envied for the broad social and political force of his work and personality.

In the end, and despite the initial misgivings of some established Adams' scholars, the idea of giving voice to a host of new approaches to the photographer's legacy and legend proved extraordinarily fruitful. Those who attended the Ansel Adams Scholars Conference were rewarded by hearing not only the original papers published here but also the presentations of David P. Peeler, Amy Rule, John Sexton, Jonathan Spaulding and William Turnage. From this rich and diverse collection of critical approaches and aesthetic positions came at least one clear conclusion: much more research, writing and thinking needs to be done. Ansel Adams, the man and the career, remains an intriguing and inexhaustible subject.

Note: The proceedings of the Ansel Adams Scholars Conference were recorded on cassette tapes; the tapes have been made a part of the Ansel Adams archive at the Center for Creative Photography, Tucson. Copies are also on file at The Friends of Photography, San Francisco.

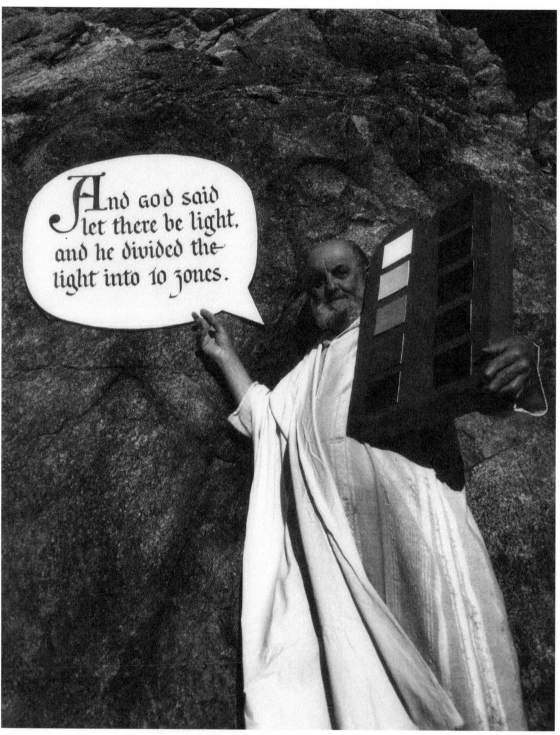

Figure 1 K.A. MORAIS, *The Ten Commandments* , 1977

ANSEL ADAMS:
THE MAN AND THE MYTH

The landscape in Ansel Adams' best known photography is, of course, the BIG country of the American West. Yet in his old age, Adams himself became an even bigger subject. He turned into a mythic figure whose fame eclipsed the very work on which it was based. This status has grown still more acute since his death, until it now seems that you can't get back to the photography unless you first deal with—or maybe dispose of—the legend of the man. To accomplish this I plan to draw almost exclusively on the two canonical texts of this myth, *Ansel Adams: The Eloquent Light*, Nancy Newhall's biographical study of 1963, and Adams' own *An Autobiography*, published in 1985, the year after he died.

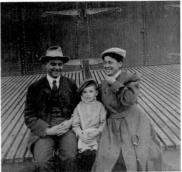

Figure 2 Ansel Adams and his parents, ca. 1907

Both books are autobiographies, really, for Newhall's, which she worked on for over twenty years, was very much Adams' own story "as told to" Nancy Newhall.[1] Just as *An Autobiography* turned out to be a joint effort with Mary Street Alinder, so was the earlier book a personal statement on which Adams worked with a trusted collaborator.

My intention is to read the words and pictures in these books as a fiction, a prose poem that follows in the tradition of various nineteenth- or twentieth-century Western—and especially American—narratives. I see these picture texts as being akin to both Walt Whitman's "barbaric yawp" and William Wordsworth's "emotion recollected in tranquility." The two works together present a portrait of Adams as a dyed-in-the-wool Romantic who was, at the same time, a struggling proto-Modernist.

The first chapters of *An Autobiography* suggest that Adams had a conventional Victorian boyhood. His adventures might be something straight out of Booth Tarkington, as when he reported a confrontation with a grade-school bully: "I knew nothing about boxing, but in my blind wrath I swung my fist like a pendulum and swatted him as hard as I could on

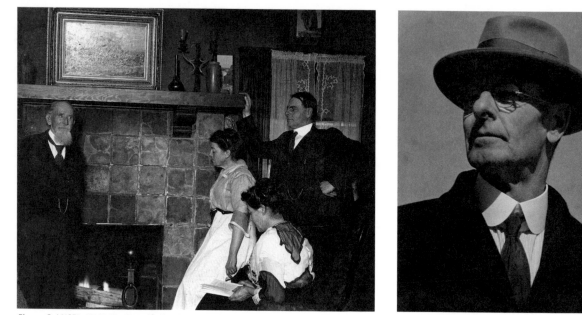

Figure 3 ANSEL ADAMS, *Grandfather Bray, Mother, Aunt Mary, and Father in our Living Room*, 1918.

Figure 4 ANSEL ADAMS, *My Father*, 1930s.

the chin. To my amazement he toppled over and passed out cold."[2]

There also hangs over the narrative in the autobiography a recognizably Victorian imperturbability. Thus does his family rise to the crisis of the 1906 San Francisco earthquake in which both chimneys on the family home collapsed. As soon as the shocks subsided, Adams says, "Mr. Connor [a house guest] and Kong [the cook] moved the stove outside, and by ten o'clock a breakfast was ready....I am sure my father, if present, would have recorded it all with his Brownie Bullseye box camera."[3]

Adams says, "My childhood was very much the father to the man I became,"[4] and in some ways the Victorian character of this first chapter in *An Autobiography* does carry over into the rest of his account of his life. This is most noticeable in his writing style, which tends towards grandiloquence. He can't say, "I was born," for instance, but rather, "I emerged into this world."[5] And 354 pages later, he contemplates not dying, but the moment "When I depart this sphere."[6] When he admits at one point, "A strange anachronism persists in most conservation literature,"[7] we can't help thinking that this is true above all of his own prose.

Yet, from the beginning, there are also signs of a precocious (not to say priapic) character too large to be contained by this Victorian world. For one thing, he is very much a Nature Boy who is too uninhibited for the proprieties of the times. This is very apparent in the passage where *An Autobiography* tells us how "I pondered the beginnings: wherefrom and how had I entered life? I asked these questions of my mother; she merely shook her head. I enjoyed a prepuberty erection in the bathtub and asked, 'What is *that*?' Again my mother shook her head."[8]

His relationship with his mother seems to have been strained, but he was inspired by his admiration for his father, whom he saw as having had his potential stymied by an era inauspicious to his character. A *very* Victorian family portrait Adams saved is a curious

document in this regard, for on looking closely we see that father is not as much the Victorian man of substance as his stalwart posture might imply (figure 3). On the contrary, the elder Adams appears a quite spiritual being since we can see right through him in places. This is only because he moved before the exposure was complete. Nonetheless, the impression the picture makes, in spite of his stolid pose, is of someone who has escaped from this stuffy setting and left only a trace behind.

A shot of him alone taken more than a decade later has a similar implication of a man with a higher vision (figure 4). In this portrait, we look up to him as he looks up or away to some still higher truth that we cannot see, or rather, that we can see only as it is reflected in his craggy visage. This is how Ansel himself so often looks in the portraits of him included in both the autobiography and Newhall's *The Eloquent Light*. His gaze out into nature is in effect a Romantic vision, and one of a particularly and peculiarly American sort. It is a Transcendentalist vision (figure 5).

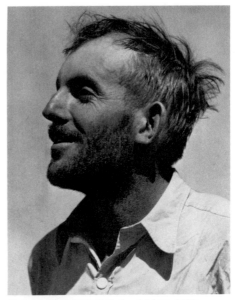

Figure 5 CEDRIC WRIGHT, *Ansel Adams*, 1930s.

Adams' vision of nature developed, in fact, in a characteristically Transcendentalist way, moving constantly over the course of his career from the microcosm to the macrocosm, from the smallest detail of nature to her Grand Design, from close inspections of what was at hand to as far as the eye could see, and searching always for a relationship between the two. Adams' preference for the lens setting "*f*/64," at least where his own photography was concerned, is important because the resulting depth of field permitted the minutiae of the near foreground to bear relationship to the grandeur of the distant background. In a typically famous photograph like *Mount Williamson, Sierra Nevada, From Manzanar, California* (plate 4), this mythological conception of nature is, more than any aesthetic debate about photography, what requires the sharp focus throughout.

I've always thought that Adams' 1944 picture *Winter Sunrise, Sierra Nevada, From Lone Pine, California* (plate 5) gained its enormous popularity because it functions as a summary image of his vision. It condenses into one photograph an idea implicit in his *oeuvre* as a whole. The way that the dark horse relates to the patch of sunlight in which it stands is repeated, on a higher plane, by the way the foothills relate to the snow-covered mountains beyond. Thus the organic nature of the horse and trees in sunshine is equated with the primordial and geological time of the earth and rocks. Thus, too, the most transient of effects—the movement of the light and the free-range grazing of an animal—is related to the most fixed and permanent features of the landscape.

We cannot doubt that Adams himself was completely aware of these different levels of meaning in his image even as he took it. In *An Autobiography*, he recalls how he agonized over whether to wait for the horse to turn sideways, fearing that in the meantime he might lose the patch of sunshine.[9] But he knew that like earth, air, fire, and water, the four elements of this picture (earth, air, shadow, and light) had to be in absolute harmony. If the parallel wasn't perfect among them so that the alternations of light and dark could be read by the viewer as surely as the striations in rock are by the geologist, the effect of the whole would be lost.

A 1982 Friends of Photography catalogue for the exhibition *The Unknown Ansel Adams*, an effort through which the photographer attempts to "define my personal photographic credo" begins with the assertion, "A great photograph is one that fully expresses what one feels, in the deepest sense, about what is being photographed, and is, thereby, a true manifestation of what one feels about life in its entirety."[10] Such ability to move from the particular to the universal is the *modus operandi* by which all Transcendentalist vision progresses.

My impression is that, over the course of his career, in what he exhibited and published, Adams moved from a high percentage of intimate pictures (that is, images of the details of nature) to increasing devotion to a more panoramic, all-embracing view. In his 1936 show at Alfred Stieglitz's gallery An American Place, over half the photographs seem to have been of the former type. But in the 40s the emphasis shifted toward the latter, and pictures in what has since been called his "operatic" mode dominated both the work itself and the way he presented it from then on.

Beginning from this sort of close observation and building toward the big picture, Adams' photography becomes one of the more powerful re-statements of Romanticism in modern times, and he becomes in many ways a pure projection of the Romantic artist. As he recounts his career in both *The Eloquent Light* and the autobiography, the photographer in him is an outgrowth of the naturalist, and the naturalist an outgrowth of nature itself. The prose that reflects this side of his personality is very different from that of the Victorian autocrat heard earlier. When this mood is upon him, Adams yearns in classic, indeed often rather cliché, terms for a Romantic merging with Nature.

"[A] large granite mountain cannot be denied—it speaks in silence to the very core of your being," he wrote for the *Sierra Club Bulletin* in 1932. "[T]he disciples are drawn to the high altars with magnetic certainty, knowing that a great Presence hovers over the ranges....[T]he spirit was gently all about you as some rare incense in a Gothic void. Furthermore, you were mindful of the urge...to enter the wilderness and seek, in the primal patterns of nature, a magical union with beauty."[11]

In the grip of such emotions, his experience of Nature becomes almost mystical, as an undated fragment reproduced in *The Eloquent Light* suggests: "The Galaxy, a vaporous plume of white fire, poured down the southern sky....The stars loomed with terrifying brilliance, the darkness beyond them throbbed with unseen light....[T]he vision of this actuality became but the shadow of an infinitely greater world, that I had within the grasp of consciousness."[12] The result, he tells us a bit later, is "almost a rebirth; I sense another and much deeper personality within me, a greatly extended perception and appreciation."[13]

As time passes, the correspondence between himself and the natural world grows ever closer. He tells us that a thunderhead drifting over Half Dome in 1937 "was so big and clear and brilliant that it made me see many things that were drifting around inside of me."[14] In the book's narrative, this parallel he senses is sometimes transformed into a fusion. His adventures function as little homilies demonstrating how he and his camera are One with Nature. In fact, he himself becomes at times a kind of natural phenomenon.

In the opening scene of *The Eloquent Light*, for example, he comes into an all-night cafe at dawn, arriving "like a whirlwind" and so enlivening this sleepy place that "It is as if the sun had come up."[15] On another occasion when he hikes to a high camp site, it is discovered

upon his arrival that as he ascended a baby woodpecker had nested in his hat. Even when catastrophe strikes in the form of a 1937 fire that consumes 5,000 of his Yosemite negatives, he treats it in Newhall's account as if it's just part of a natural cycle of burn-off and renewal, springing back at once with the observation, "I'll...go after Yosemite again with a new point of view."[16] It seems perfectly natural, literally, when the famous San Francisco earthquake inscribes itself upon him by knocking him over and giving him an almost equally famous broken nose, which zig-zags down his face forever after like a fault line down the California coast.

Perhaps the place where we see most dramatically his merger not just with nature, but with the Cosmos, with the whole natural order of things, is in the act of discovery of photography itself. Catching measles at age 12, he was put to bed in a dark room where "The spaces between the shade and the top of the windows...served as crude pinholes, and vague images of the outer world were projected on the ceiling."[17] The way he describes them, the bedroom, the source of the light, and the disposition of the figures outside are a veritable reconstruction of Plato's Cave; therein he discovers for himself, at their source, the principles of the *camera obscura*.

An incident that occurred with his first Brownie camera on his first visit to Yosemite is at least as symbolic, if not downright preposterous: "I climbed an old and crumbling stump...to get a picture of Half Dome. I...was about to snap the shutter when the stump gave way and I plummeted to the ground. On the way down, headfirst, I inadvertently pushed the shutter."[18] The result was an inverted image (just like those in Plato's Cave) that was one of his favorites from his first year of photography.

The way this episode is presented, it is as if nature itself took the picture—as if nature were using him as an instrument the way he might use the camera. Nature speaks through him in the same manner that, the Romantics felt, it spoke through them. Reflecting on both *Moonrise, Hernandez, New Mexico*, and *Winter Sunrise* (plate 5), he told Nancy Newhall, "Sometimes I think I do get to places just when God's ready to have somebody click the shutter!"[19]

Adams' self-image has in it so much of what is essential to an American Romantic, it embraces so many aspects of the Transcendental, that he might proclaim along with Walt Whitman in *Song of Myself*, "I am large/ I contain multitudes." What this largeness of character means, for Adams as for Whitman, is that he contains a good many contradictions; he embodies a certain American dialectic that gives him his reach as a public personality.

We've already seen this variousness, and its occasional inconsistencies, in several aspects of his career—in the disparity between Victorian grandiloquence and Romantic mysticism in his prose, or in the Transcendentalist's play-off of the minute detail against the vast panorama in his photography. The leap of faith required to get from the microcosm to the macrocosm is a contradiction inherent in Transcendentalism itself, which includes not only Emersonian Grand Designs and eternal truths, but Thoreau's almost scientific, empirical love of close observation and rigorous exactitude.

In Adams the conflict between these two impulses takes the form of an alternation between the intuitive genius of the camera and the photo-technician who writes a series of highly informative, very practical how-to books. "Adams can tell you the brightness

reflected by any object...so accurately that if one of his meters disagrees with him, he suspects it is out of adjustment, and...is usually right," Newhall informs us in one sentence.[20] But then in the next she reports Adams' "abhorrence" of "the fuzzy-headed trust many photographers...put in 'feeling the light.'"

Yet another way to view the two-mindedness of which Adams was capable is as a disagreement between the Romantic in him and the equally vociferous Modernist. The need to reconcile the two was revealed in the way he defended himself against a 1933 attack made on his work by the West-Coast porno-Pictorialist William Mortensen. Explaining the hard-edged, clear-eyed character of objective—as opposed to subjective—photography, Adams said, "All great art in any medium avoids weak sentimental-subjective conceptions. [But] the objective attitude in no way implies that photography is not emotional[O]bjectivity is only the tool of intense expression."[21]

At the same time that he was obviously a Romantic visionary in one regard, Adams was also a founder of Group $f/64$, and one of the framers of its "Manifesto" declaring the members to be advocates of "Pure Photography," which was defined as "possessing no qualities of technique, composition or idea, derivative of any other art form."[22] Nothing could be more basic to Modernism than this program for exploring and elucidating one's medium on its own terms.

At its most all-encompassing level, the contradiction here is one between the Ansel Adams who is merely an extension or outgrowth of a natural world that speaks through him, and another Ansel Adams who claims to be completely *sui generis*. We find traces of the latter throughout Adams' development. First there is the lad who only went to school through eighth grade before quitting (with his father's blessing) and thereafter was completely self-educated. Then comes the youngster who discovered Yosemite for himself, dragging his family there on a hunch when they wanted to go on vacation elsewhere. And finally we arrive at the adult who claimed that at the point when he chose a career in photography over one in music, he knew almost nothing of photographic history or his artistic predecessors.[23]

Perhaps it was inevitable that the humility of the naturalist before nature would be overridden at some point by an egotism, an aesthetic hubris, necessary to the artist. Overweening self-creation of this sort—or at least self-proclamation—is intrinsic to artists from Romantics like Wordsworth to Modernists like Stieglitz. Adams was simply fulfilling the tradition when he declared, in the Group $f/64$ Manifesto, that photography must be a totally self-referential and self-sustaining art form. And Wordsworth was in a sense founding that tradition when he declared, in words anticipating Adams' own quoted above, "The child is father of the man." This is the most audacious dream of self-sufficiency ever.

For Adams, the range of the self, like the range of the light, goes from one extreme to another. It runs the gamut from a high-minded idealist-Transcendentalist to the kind of John Wayne parody of the Westerner we find on the first page of *The Eloquent Light*, when comes into that all-night cafe "like a whirlwind, laughing and stamping," commanding everybody's attention by his sheer presence as he "...sings out, 'You got a steak out there? Can I have it rare?'"[24]

Adams' artistic persona encompasses both the lofty Transcendental heights of Emersonian self-reliance and the much earthier, Bully-Pulpit rugged individualism of great American outdoorsmen like Teddy Roosevelt. The dualism we sense in his development reaches back to some of the earliest mentors and colleagues introduced in Newhall's book,

where a temperamental tension is unmistakable between the old sourdoughs on the one hand, and the sensitive souls on the other.

Adams is a summary figure not only of the history of art from Romanticism through Modernism, but of the history of America from New England, where his forebears on both sides were born, to California. With one set of grandparents coming by ship from Maine and the other coming from the East overland by wagon, Adams fell heir to the heritage not only of New England Transcendentalism, but also to Manifest Destiny.

The result is that Adams' background and character are so large, they contain so many multitudes, that he ultimately becomes a subject superceding nature itself. *He* becomes the subject of his exhibitions. This final phase of his career I trace from the 1963 exhibition *The Eloquent Light*, which was mounted at the De Young Museum in San Francisco. The exhibition contained not only photographs, but also mementos, keepsakes, and items from Adams' personal collection, including pottery, gravestones, rocks, lichened branches, living trees, etc.—a total of 500 objects dating back to the 1920s. From that exhibition almost 30 years ago to the memorial conference in Carmel for which this paper was prepared, the one danger inherent in Adams' heritage has been that the legend might eclipse the work, which was finally far more important to him than his fame.

NOTES

1 Containing less than 100 pages of text, *Ansel Adams: The Eloquent Light* traces Adams' career only to 1938 and was to be the first installment of a two-volume study of his life. A second volume entitled *The Enduring Moment* exists in manuscript form as part of the Adams Archive at the Center for Creative Photography in Tucson. Access to it has been restricted by Beaumont Newhall, however, perhaps because the text was left in a very fragmentary, incomplete, and therefore potentially misleading form at the time of Nancy Newhall's death.

2 Ansel Adams with Mary Street Alinder, *Ansel Adams: An Autobiography* (Boston: Little, Brown and Company, 1985), 16.

3 Adams with Alinder, 7.

4 Adams with Alinder, 4.

5 Adams with Alinder, 5.

6 Adams with Alinder, 359.

7 Adams with Alinder, 216.

8 Adams with Alinder, 13.

9 Adams with Alinder, 262-63.

10 Adams with Alinder, 235.

11 Adams with Alinder, 143.

12 Nancy Newhall, *Ansel Adams: The Eloquent Light* (New York: Aperture, 1963), 36.

13 Newhall, 43.

14 Adams with Alinder, 37.

15 Newhall, 13.

16 Newhall, 139.

17 Adams with Alinder, 49.

18 Adams with Alinder, 53.

19 Newhall, 17.

20 Newhall, 17.

21 Adams with Alinder, 114.

22 Adams with Alinder, 112.

23 Adams with Alinder, 110.

24 Newhall, 13.

P L A T E S

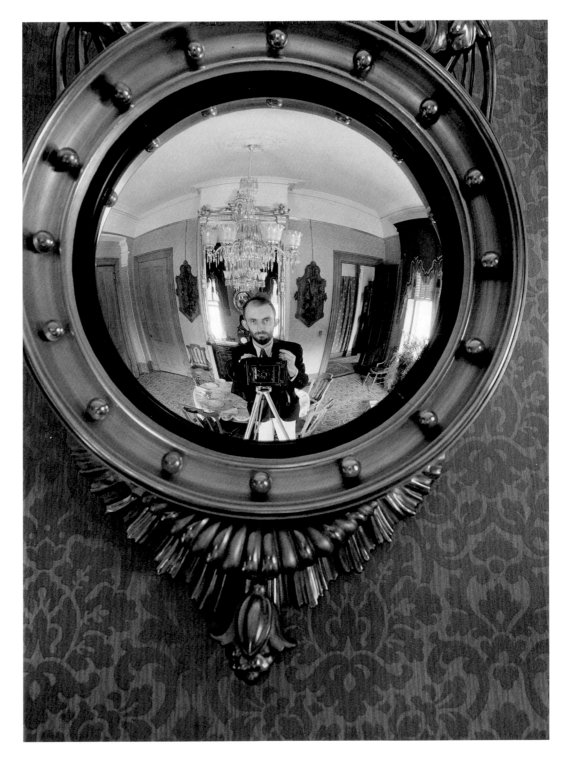

Plate 1 ANSEL ADAMS, *Self Portrait in a Victorian Mirror, Atherton, California*, 1936.

Plate 2 ANSEL ADAMS, *Self Portrait, San Francisco*, 1936.

Plate 3 ANSEL ADAMS, *Self Portrait, Monument Valley, Utah*, 1958.

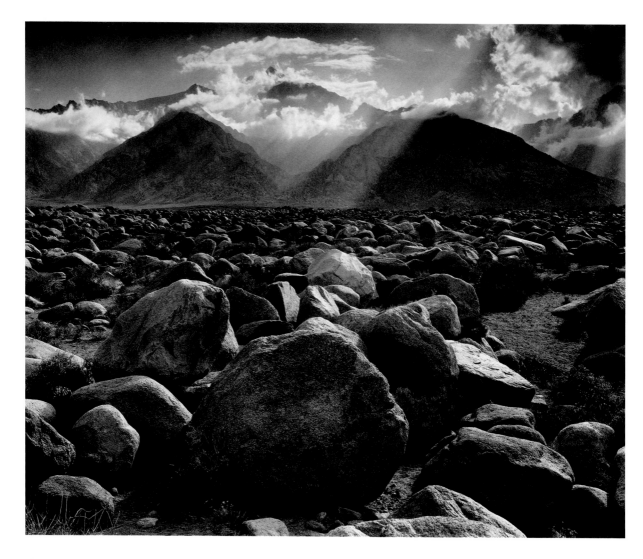

Plate 4 ANSEL ADAMS, *Mount Williamson, Sierra Nevada, From Manzanar, California*, 1944.

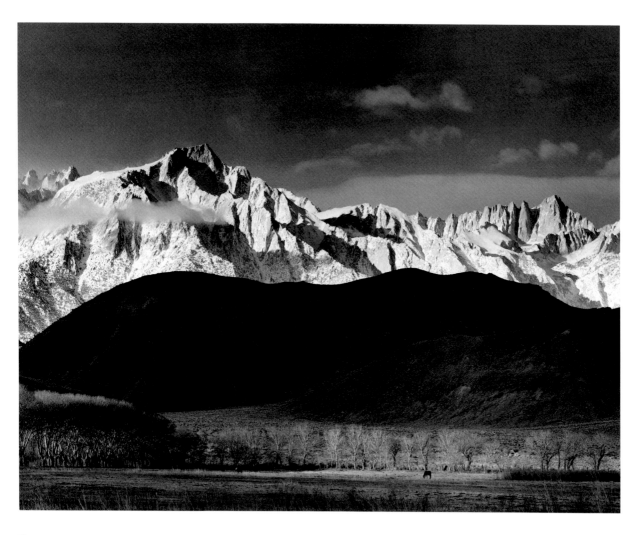

Plate 5 ANSEL ADAMS, *Winter Sunrise, Sierra Nevada, From Lone Pine, California*, 1944.

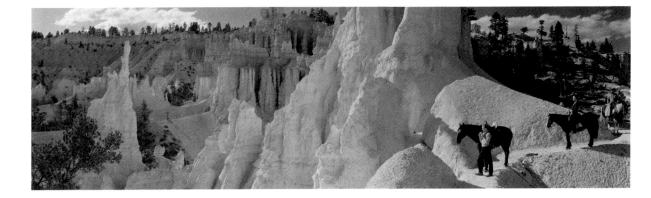

Plate 6 ANSEL ADAMS, Colorama #69, Yosemite National Park, 3/29/54. This Colorama included two overlaying snapshots, now missing.
©Eastman Kodak Company.

Plate 7 ANSEL ADAMS, Colorama #75, Bryce Canyon National Park, 8/2/54. ©Eastman Kodak Company.

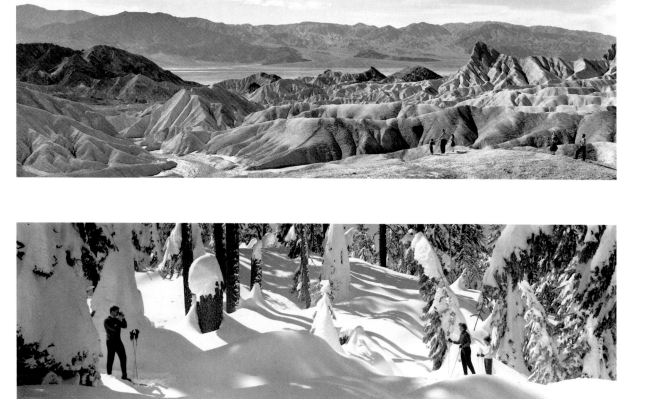

Plate 8 ANSEL ADAMS, Colorama #157, Zabriske Point, Death Valley, California, 8/24/59. ©Eastman Kodak Company.

Plate 9 ANSEL ADAMS, Colorama #215, Near Badger Pass, Yosemite National Park, 1/7/63. ©Eastman Kodak Company.

Plate 10 ANSEL ADAMS, *Grass and Water, Tuolumne Meadows, Yosemite National Park,* 1935.

Plate 11 HARRY CALLAHAN, *Weeds in Snow,* 1943.

Plate 12 ANSEL ADAMS, *Surf Sequence, San Mateo County Coast, California,* 1940. (Four from a series of five.)

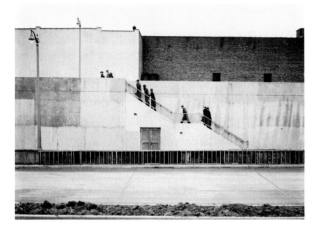
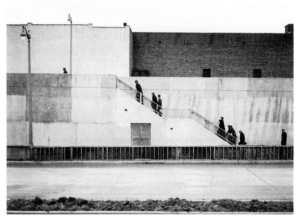

Plate 13 HARRY CALLAHAN, *Highland Park, Michigan,* 1941

Plate 14 DOROTHEA LANGE, *Raentsh Portrait, San Francisco*, 1932

Plate 14 ANSEL ADAMS, *Carolyn Anspacher, San Francisco,* 1932.

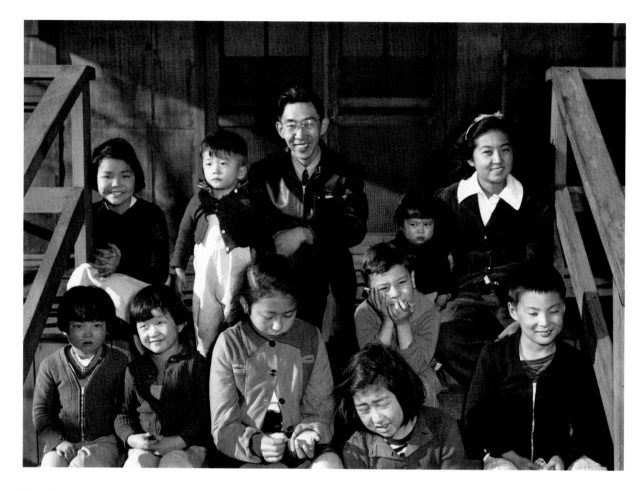

Plate 16 ANSEL ADAMS, *Mr. Matsumoto and Children*, 1943, from *Born Free and Equal*

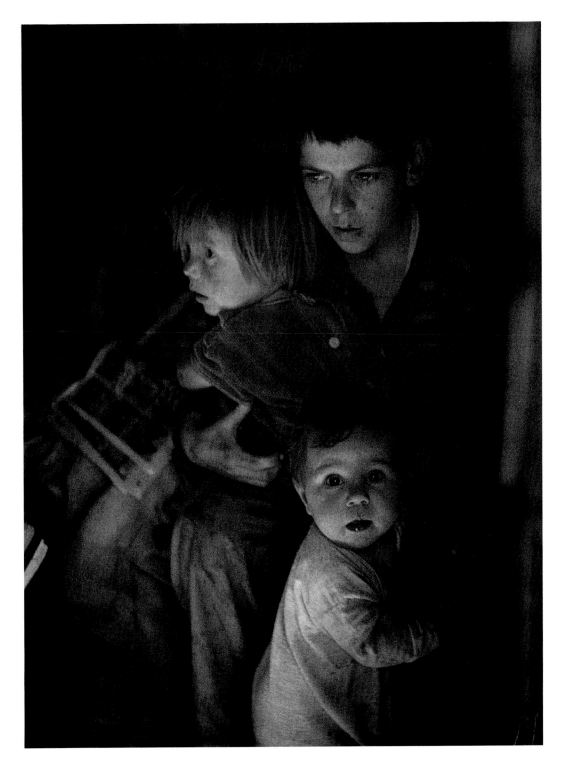

Plate 17 ANSEL ADAMS, *Trailer Camp Children, Richmond, California,* 1944.

Plate 18 CEDRIC WRIGHT, *Ansel Adams in Sierra Foothill (near Bishop),* 1945.

Robert Silberman

SCALING THE SUBLIME:
ANSEL ADAMS, THE KODAK COLORAMA
AND "THE LARGE PRINT IDEA"

*[T]here are many who are now trying the large print idea—and I shudder at some of
the results! Also—I am happy over some; but it is a conceptual problem; not just
blowing up pictures which look blow-upable!*
—Ansel Adams to John Szarkowski, October 23, 1962[1]

Ansel Adams was always aware of the big picture. Not, in this case, the meaning of life or
the fate of the world, but rather large images, and the conceptual, perceptual, and technical
problems they posed. In Adams' long career, his abilities in relation to "the large print idea"
were never more clearly displayed than when he made photographs for the Kodak
Colorama in Grand Central Station in New York. The Colorama was a transparency, not
a print, but it was undeniably a large picture. Not a "pretty big" picture or a "rather large"
picture, it was in its time the blow-up to end all blow-ups: 18 by 60 feet.

Fourteen Coloramas in the 1950s and 1960s used Adams images, including photographs
taken in Yosemite, Death Valley and Bryce Canyon. Adams said in his autobiography that
the Coloramas were "aesthetically inconsequential but technically remarkable."[2] Yet that
judgment, however understandable, needs qualification, since his work on the Coloramas
is instructive about more than technique. The Adams Coloramas provide an important
perspective on his other projects involving large images, and a guide to his ideas about scale
in picture-making. They also help us understand his characteristic ways of depicting the
physical world, and in particular his reliance on an aesthetic tradition based upon the
concept of the sublime. Adams' work with large prints and the Colorama therefore is related
to "the big picture" in a non-pictorial sense, insofar as it helps teach us about Adams'
philosophy of nature, a central concern in his life and art (plates 6, 7, 8 and 9).

In all, five hundred and sixty-five Kodak Coloramas were installed in Grand Central
Station from 1950 until 1990 (figure 6). The Colorama aimed at a broad popular audience.
It was originally intended to provide "a dramatic series of pictures of the kind everybody

likes, with the aim of promoting photography generally and Kodak color products in particular."[3] Initially, it was accompanied by a "photo information center" where Kodak employees offered technical information.[4] Called "America's Family Album" by the *Saturday Evening Post*, the Colorama had as its main theme, as Norman Kerr remarked, "Americana, a view of America as an ideal that is nostalgic in the best sense of the word."[5] Many of the early images are, in retrospect, more than a bit corny. They are also at times pleasantly if comically appealing, as are so many aspects of 1950s life when filtered through a 1990s sensibility. In 1958, for instance, Ozzie, Harriet, David, and Ricky Nelson appeared along with Ed Sullivan in a Colorama boosting "the Kodak Camera Carnival." As the series went on, pictures of children's choirs for Christmas, postcard-like "scenics" and family vacation shots appeared regularly, along with baby pictures and still lifes of Kodak products. But there were also images of the astronauts on the moon (the ultimate tourist shots), Eliot Porter photographs of Antarctica, and a semi-abstraction by Gordon Parks.

The Colorama was sometimes a single image, sometimes a composite divided into three or more sections. At first the Colorama was created from several joined negatives. On occasion a Deardorff banquet view camera was used. Images were even made from 35mm negatives, because what originally required a foot-and-a-half negative later took an inch-and-a-half one.[6]

In 1990, when the preservationists had not only saved Grand Central Station from the wrecking ball but determined to restore it to its original splendor, the Colorama was ousted as a late, "inauthentic" addition, even through it had become something of an historic architectural and cultural feature in its own right. The Kodarama, a larger image (30 by 50 feet) but not such a radically horizontal one, was installed in 1985 in Times Square, where it remains today.

The pictures made by Adams for the Colorama are an exceptional example of his commercial work. Adams wrote Stieglitz in 1933 that "creative work is one thing and 'commissions' are another."[7] That helps to explain why he might be less than pleased, in aesthetic if not business terms, by the work he did for the Colorama. In practice, however, for Adams the division between art and commercialism was never absolute.[8]

Adams suggests in *The Print* that for a "very large print" a relatively abstract pattern is preferable to a more representational image.[9] The Coloramas, in contrast, were mainly scenic landscapes or relatively close-up shots of people. As landscapes, they featured large-sized sections of the world, depicted on a grand scale, but with an unusual format. Over the past few decades photographic antiquarianism, the desire for an alternative to the standard formats (35mm, 2 1/4, 4 by 5) and the search for a format appropriate for particular subjects have led any number of photographers to experiment with the panoramic camera, from Art Sinsabaugh and Jerry Dantzic to Frank Gohlke, Josef Koudelka, Michael Smith, and Mark Klett. In the nineteenth-century, panoramas were not so rare, being produced for example by Muybridge, Watkins, and Jackson. But in the 1950s the Colorama format must have been something of a freak. That was also before print sizes became progressively larger, as photographers shifted from 8 by 10 or 11 by 14 inch prints to ever bigger, if not necessarily better, images.[10]

The panoramic tradition in American art extends beyond American photography, and helps provide a background for the Kodak colossus. The Colorama, as a grand scale image designed for the general public, recalls eighteenth- and nineteenth-century prototypes. In the

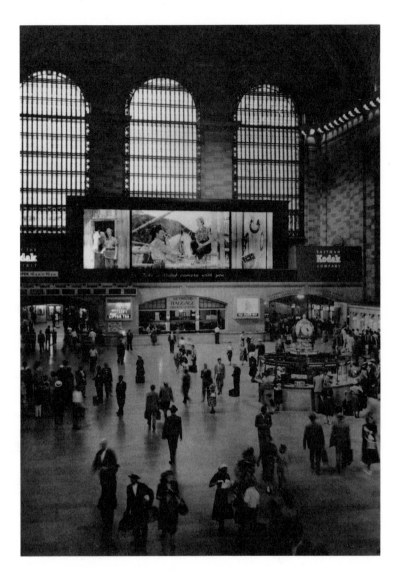

Figure 6 Kodak Colorama installation view, Grand Central Station, New York City. The Colorama pictured is not by Adams.

days before movies and omnitheaters, panoramas were large paintings installed in specially-designed spaces. Either the viewers stood on a platform in the center and turned to look at the image installed in a circle around them, or the image was unrolled and scrolled past them—a moving picture. These pictures could be enormous: an early one in Paris measured 110 by 16 meters. They often depicted distant, exotic landscapes or recent battles. Henry Lewis' *Mammoth Panorama of the Mississippi River*, painted on 45,000 square feet of canvas, represented the "father of waters" from St. Louis to Minneapolis. Like some of the Coloramas, including the ones by Adams, it presented Western scenery to Easterners.[11] Most panoramas wore out, or were lost or destroyed, including a 50 by 380 foot canvas of Yosemite by Charles Dorman Robinson. But there are panoramas extant in Atlanta and Gettysburg depicting Civil War battles, and others in Germany, Poland, Russia, Iraq, and North Korea.

Wolfgang Born argued more than forty years ago that "the panorama was in harmony with an innate trend of the American mind, then only in its preliminary stage but destined to grow from year to year; a trend toward the realization of the vastness of the country, of its unlimited horizon."[12] The panorama was, in effect, made for the American West, because it emphasized grand vistas and extended horizontals. In that light, the apotheosis of the panoramic tradition in American painting is to be found in Georgia O'Keeffe's late *Sky Above Clouds* series.[13]

Another pictorial tradition, related to the panoramas, also stands behind the Colorama. In the nineteenth-century, the most noted American artists painted what were called "Great Pictures." In Linda S. Ferber's description, a "Great Picture" is "a very large painting exhibited publicly and conceived in subject to appeal to a wide spectrum of popular taste." She notes, "In the conception, presentation, and promotion of their 'Great Pictures,' [Albert] Bierstadt and [Frederick] Church employed many of the devices and strategies associated with the diorama and the moving panorama....These presentations combined large-scale scenery with dramatic effects of light in a kind of pre-cinematic theatre experience."[14] The exhibition of a "Great Picture" could be a major public event. Church's *Heart of the Andes*, a painting 66 by 119 inches, earned the artist $3,000 in admissions and $6,000 in subscriptions for the proposed engraving when shown in New York for three weeks in 1864. It managed to be, in Franklin Kelly's words, "both serious art and popular entertainment."[15]

Church's first "Great Picture," the one that made his reputation, was of Niagara Falls. That image and subject reflect the concept of the sublime as it entered aesthetic theory and pictorial practice and, ultimately, the photography of Ansel Adams. The theory of the sublime reserved the highest aesthetic honors for images of landscapes representing scenic grandeur, preferably of an awesome, even horrifying kind that would inspire "delightful terror." "Sublime" often meant elevated in altitude as well as sentiment. (There is a "Point Sublime" at the Grand Canyon). As Barbara Novak observed, following Edmund Burke, the sublime "was associated with fear, gloom, and majesty. Majesty had to do with scale and size, exemplified particularly by mountain scenery. The sublime...provoked intimations of infinity and thus of Deity and the divine. It was an overwhelming divinity, dwarfing the observer who, though he aspired to transcendence, rarely forgot his own insignificance."[16] For Kant, as Samuel Monk tells us, sublimity was associated with "natural cataclysms— lightning, storms, mountains, waterfalls...the sublime reflected overwhelming natural energies. Nature was often conceived of as wild and savage."[17] In America in particular, under the Transcendentalist influence, wildness and wilderness became signs of a more direct relation to deity.

The beautiful, the complement and intellectual twin of the sublime, was in a distinctly lower key, more harmonious and varied, and less threatening. When Wordsworth writes in *The Prelude* (XI, 305-6) "I grew up/Foster'd alike by beauty and by fear," he is speaking of being nurtured by the beautiful and the sublime. A third term, the picturesque, is harder to pin down, since it is concerned with visual elements defined in relation to composition— form, line and perspective. As Anne Hyde notes, "The picturesque did not describe raw nature: it meant nature artfully designed so that it could be read like a picture. A picturesque scene offered the clear compositional elements present in a proper painting: carefully defined near, middle and far distances and a balance of light and shade to harmonize the

scene. The picturesque permitted nothing startling, surprising, or wild; its purpose was to charm the viewer."[18]

One of the questions confronting Americans was whether the American landscape had any vistas to offer comparable to those that had stimulated the European masters. Thomas Cole, the first great American landscape painter, wrote in his 1835 "Essay on American Scenery" that there were those "who through ignorance or prejudice strive to maintain that American scenery possesses little that is interesting or truly beautiful—that it is rude without picturesqueness, and monotonous without sublimity—that being destitute of those vestiges of antiquity...it may not be compared with European scenery." Cole did not stop there, however. He went on to insist that "nature has shed over *this* land beauty and magnificence, and although the character of its scenery may differ from the old world's, yet inferiority must not therefore be inferred." Niagara, as a natural wonder, was a godsend for cultural chauvinists, who could praise it as the equal of anything to be found in Europe. Cole wrote, "Niagara! that wonder of the world! —where the sublime and beautiful are bound together in an indissoluble chain."[19] Not coincidentally, Church used Niagara as the subject of his first great success, and much later it twice served as the subject of a Colorama.

Yosemite came to play a similar role in the service of what Hyde calls "scenic nationalism."[20] Thomas Starr King wrote, "Nowhere among the Alps, in no pass of the Andes...is there such stupendous rock scenery."[21] Paintings such as *The Rocky Mountains, Lander's Peak* , ca. 1863, support Nancy K. Anderson's observation that for those "who sought the American sublime, Bierstadt invented mountains to match the Alps...an iconic image of Manifest Destiny." But Anderson goes on to say that for Bierstadt, Yosemite was a "scenic gold mine," freeing him from the need to create an imaginative "American equivalent for the European sublime." He could return to more literal depiction, since the grandeur of Yosemite offered "a national landscape for which there was no equivalent."[22]

Ansel Adams is the great heir and representative of this tradition of the American sublime, as can be seen by comparing, say, his photograph *The Tetons and the Snake River, Grand Teton National Park, Wyoming,* with Bierstadt's 1868 painting *Among the Sierra Nevada Mountains.*[23] Adams was deeply indebted to nineteenth-century landscape aesthetics, and held a relatively conservative notion of what constituted aesthetic beauty, including the sublime. Yet no matter how great his devotion to his nineteenth-century predecessors in painting and photography, Adams at times follows a decidedly modern notion of pictorial form, as can be seen in *Frozen Lake and Cliffs , The Sierra Nevada, Sequoia National Park,* no standard nineteenth-century view. He also had his own notions about what constituted "the artistic," as is evident in a comparison of unmanipulated prints of *Monolith, The Face of Half Dome, Yosemite National Park,* and *Moonrise, Hernandez, New Mexico* with the "interpretive" prints.

The Coloramas were not Adams' first project involving large-scale images. In 1935 the Yosemite Park and Curry Company commissioned him to make mural-sized (40 by 60 inch) prints for the San Diego Fair. What has come to be known as The Mural Project involved 225 prints made in 1941-42 as part of a proposal to make photographic murals for the Department of the Interior. Although the war prevented the final realization of the murals, this project was prepared for by the creation of a screen that Adams sold at a discount for the office of Harold Ickes, Secretary of the Interior. In writing the proposal for his project, Adams stated that "photo-murals, because of the obvious limitations of the medium of

photography, must be simpler [than paintings]—either purely decorative (such as the Screen in Secretary Ickes's office), or forcefully interpretive. I do not believe in mere big scenic enlargements, which are usually shallow in content and become more tiresome in time."[24] The images for a 9 by 12 foot photo-mural (now destroyed) for the offices of the Yosemite Park and Curry Company office in San Francisco and for the Ickes screen, as well as the one for a screen made for the bottom of the staircase at Best's Studio suggest what Adams meant.[25]

Adams was by no means the only photographer of his time concerned with photographic murals, which he described as "enlargements with a vengeance."[26] In 1932, the Museum of Modern Art presented a little-known but fascinating exhibition organized by Lincoln Kirstein and Julien Levy entitled *Murals by American Painters and Photographers*. Some of the images have become classics, for instance the Thurman Rotan skyscraper montage and the Charles Sheeler triptych, *Industry*.[27] At the World's Fair of 1939, the Kodak *Cavalcade of Color* exhibit featured large projected images, a method tried unsuccessfully in Grand Central, where the ambient light forced the use of a transparency lit from the rear. During World War II, a Kodak display in Grand Central used 22 pictures to create an installation 100 by 118 feet that clearly anticipated the Colorama. In the Coloramas, photography as the modern medium and billboard display as a mass culture phenomenon neatly dovetailed.[28] As a showpiece for a photographic corporation, the giant transparency in a key metropolitan junction made perfect sense.

Among the Adams Coloramas are several scenics that deliberately exploit the horizontal sweep of the land and the grand vistas. These neatly illustrate Born's remark that the panoramic tradition in painting exploited a "new pictorial principle...equivalent to the wide-angle view in photography."[29] In the Coloramas, Adams uses figures as part of the advertising program, since it was a standard scenario to feature people taking photographs. An Adams Colorama winter scene shows a group of skiers with one taking a picture of the others. The scene is stagey, if competent. In contrast, the images on several of the decorative screens do not contain people, but instead concentrate on the forms of snow-laden trees. Adams could be a fine portraitist, yet it is hard to disagree with David Robertson's assertion that integrating people with the landscape was not his forte.[30] The people in the Coloramas of course do more than sell Kodak products by acting as viewer surrogates, objects of identification for would-be consumers. As in the "Great Pictures" of Church and Bierstadt, the figures establish scale within the image. But in Adams' "artistic" photographs of Yosemite, as in most of his best-known images, humans are as a rule absent. In 1943 Adams wrote to David McAlpin that his next phase would be "*people in relation to nature.*"[31] It seems he never followed up on that statement. Perhaps he realized that the presence of people was not appropriate for his vision of the landscape, apart from the implicit presence of the viewer. In the Coloramas, figures such as those inducing the viewers to use Kodak products no doubt disrupted a purely contemplative relationship to nature. After all, one of the basic elements of the sublime was "solitude."[32]

Looking at Adams from the admittedly special perspective suggested by the Colorama and the aesthetic discourse surrounding the concept of the sublime makes certain other aspects of his photography stand out. To begin with, we can better understand his choice of imagery, such as the special qualities of Yosemite as a site, especially its notable combination of the horizontals of river, tree lines, and valley ridges, and the verticals of Half

Dome, El Capitan, particular great trees, and the waterfalls. Moreover, we can see his considered treatment of point-of-view and vantage point. In his grand landscapes, Adams brilliantly exploits the possibilities of both elevated views and ground-level shooting. As Colin Westerbeck observed in his presentation at the Ansel Adams Scholars Conference, in the course of his career Adams became increasingly devoted to the panoramic view. Some of Adams' greatest compositions, though not in the exaggerated panorama format of the Coloramas, suggest the importance of that way of seeing by working as complex sets of horizontal bands. In addition to *Frozen Lake and Cliffs,* this is the basic structure of *Moonrise, Hernandez* and *Winter Sunrise, Sierra Nevada, From Lone Pine, California* (plate 5). These images suggest how Adams, working with his love of deep blacks and bright whites, a key aspect of his version of modernist pictorial drama, used alternating bands as the basis of his pictorial composition. *Moonrise, Hernandez* and *Winter Sunrise* suggest that Adams was more at home temperamentally in the range of the beautiful, of peaceful harmony and smooth lines, tonally and compositionally working with the classical virtues of order, harmony, and proportion. *Mono Lake, California* suggests a tranquil reflectiveness that seems a favorite mood. Nevertheless, *Clearing Winter Storm, Yosemite National Park,* like the 1870 Bierstadt painting, *Passing Storm Over the Sierra Nevada,* suggests an affinity with a more tempestuous vision of nature, even if it seems the sublime is disappearing, not gaining force, at the moment it is recorded. In contrast, the Colorama photographs, intended to suggest inviting spots for recreation and photography, offer an unthreatening view of nature. They avoid anything resembling the awesome aspect of the sublime, even though they were taken in locations that could produce images in that mode.

Adams did several 55 by 39 inch prints of *Moonrise, Hernandez.* That is not large by mural or Colorama standards, yet according to John Sexton, 20 by 24 inches was considered "oversized" for a print when he worked for Adams.[33] In a 1961 letter to Beaumont and Nancy Newhall, Adams says that he must discipline himself and not make prints too large, though printing large is "OK if appropriate!" He adds that it can become a habit, as it did when he worked on a project making large prints for Polaroid. As a corrective, he proposed that he should for a while limit himself to 8 by 10 inches. But he leaves himself an out when he states, referring to *Mount Williamson, Sierra Nevada, From Manzanar, California* (plate 4) and, apparently, *Clearing Winter Storm,* that at times "...size is necessary from the point of view of majesty and dramatic force."[34] That is, the sublime. Thus Adams saw that images involving the sublime could require larger print sizes.

When Adams wrote to Nancy Newhall of one of his images, "Like it but can't yak about it,"[35] he gave his most memorable statement of his refusal to talk about the meaning of his photographs. Yet the traditionalism of his taste, and in particular his adherence to the conventions of the sublime and the beautiful, help explain why his pictures have enjoyed such enormous popularity. Arguably, most people still hold essentially nineteenth-century notions when it comes to the depiction of the landscape.

However we judge the Colorama images as aesthetic achievements, they do help us see that in much of his work Adams is part of a panoramic tradition, an American tradition related in turn to the crowd-pleasing tradition of the "Great Picture." The Adams Coloramas served a mundane purpose in boosting photography and Kodak products. Yet beyond that they suggest the significance of the sublime and the beautiful as twin concepts shaping popular responses to the Western landscape. If only indirectly, they help us to

appreciate the depiction of nature in other Adams photographs. Adams was perfectly at home in the lyrical, intimate realms of the beautiful. But it is in photographs such as *Mount Williamson* or *Clearing Winter Storm* that we see Adams not only scaling but, in the eyes of so many admirers, arriving at the summit of the sublime.

Preliminary research on this subject at Eastman Kodak in Rochester, N.Y. was made possible by a grant from the Center for Arts Criticism, St. Paul, Minn. I would like to thank Amy Rule and Leslie Calmes, the archivists at the Center for Creative Photography, and Rod Dresser, Jeff Nixon and Andrea Stillman at The Ansel Adams Publishing Rights Trust for invaluable assistance. Above all, I am grateful to Norman Kerr, formerly of Kodak, for talking about the Colorama and Kodarama with me, and making essential materials available .

NOTES

[1] Mary Street Alinder and Andrea Gray Stillman, eds., foreword by Wallace Stegner, *Ansel Adams: Letters and Images, 1916-1984* (Boston: Little, Brown and Company, 1988), 288 (hereafter cited as *Letters*).

[2] Ansel Adams with Mary Street Alinder, *Ansel Adams: An Autobiography* (Boston: Little, Brown and Company, 1985), 174 (hereafter cited as *An Autobiography*).

[3] "Kodak To Unveil *500th Colorama...*" *Kodakery*, 41:33 (1 September 1983), 1.

[4] Kodak News Release, 15 May 1950.

[5] *Saturday Evening Post*, November-December 1973, 34; Norman Kerr, telephone conversation with the author, 1 July 1992.

[6] The first 35mm images used were five Kodachrome slides taken in 1953 on a Mt. Everest expedition. The first Colorama image based on a single 35mm image used a 1970 shot of Impalas grazing in Africa by Ernst Haas.

[7] *Letters*, 66.

[8] Adams wrote in a letter to Virginia Best on 28 September 1923, "I don't like colored photographs....Monotone is the domain of photography" (*Letters*, 19). Color film may have seemed an instrument of commercialism and mere prettiness, especially in a Colorama of a poppy field.

[9] Ansel Adams, *The Print* (Boston: Little, Brown and Company, 1983), 174.

[10] In 1983, John Pultz organized *Big Pictures by Contemporary Photographers* at the Museum of Modern Art to examine this phenomenon. He was followed in 1986 by Marvin Heiferman, who organized *The Real Big Picture* at the Queens Museum and in 1987 by Joseph Jacobs with *This is Not a Photograph: Twenty Years of Large Scale Photography, 1966-86* at the Ringling Museum. The history of the norms governing photographic print size deserves study. As John Pultz notes in his essay, "mammoth" prints—14 by 17 or 16 by 20 inches—dominated the Pictorialist camera club salons in the 1940s, when Adams was printing 8 by 10 inches, that is, modest sized prints with little or no enlarging.

[11] On Lewis, see Barbara Novak, *Nature and Culture: American Landscape and Painting 1825-1875* (New York: Oxford, 1980), 23 (hereafter cited as *Nature and Culture*). On panoramas in general, see Ralph Hyde, *Panoramania!: The Art and Entertainment of the 'All Embracing' View* (London: Barbican Art Gallery, 1988). See also Richard D. Altick, *The Shows of London* (Cambridge, Mass.: Harvard UP, 1978), esp. 128-210, 470-482; Lee Parry, "Landscape Theater in America," *Art in America*, vol. 59, no. 6 (November-December 1971), 52-61; and Martha A. Sandweiss, ed., *Photography in Nineteenth-Century America* (Fort Worth: Amon Carter Museum, 1991), 98-129. Mention should also be made of Daguerre, who was responsible for dioramas in Paris and London before turning to photography. Dioramas were spectacular illusionistic tableaux, lit from both front and rear, so that shifts in lighting could change day to night, sun to moon. They were not unlike transparencies, and exploited the illusionistic possibilities of darkened exhibition spaces with theatrical lighting playing upon the images. The Coloramas were back-lit, and except when bright daylight was piercing the gloom of Grand Central, benefited from a somewhat similar effect. See Helmut and Alison Gernsheim, *L.J.M. Daguerre: The History of the Diorama and Daguerreotype*, 2nd rev. ed. (Dover: New York, 1968). A list of diorama subjects appears on 182-186, with similarities to many Colorama subjects.

In its format, the Colorama bears an obvious relation to the wide-screen movie images popular in the 1950s when the film industry tried to fight the increasing importance of television.

[12] Wolfgang Born, *American Landscape Painting: An Interpretation* (New Haven: Yale UP, 1948), 80

(hereafter cited as *American Landscape Painting*).

13 See for example *Sky Above Clouds IV* (1965), reproduced in Georgia O'Keeffe, *Georgia O'Keeffe* (Penguin: New York, 1976), n.p.

14 "Albert Bierstadt: The History of a Reputation," in Nancy K. Anderson and Linda S. Ferber, *Albert Bierstadt: Art and Enterprise* (New York: Brooklyn Museum, 1990), 24, 24-25.

15 "Introduction," Franklin Kelly, *Frederick Edwin Church* (Washington, D.C.: National Gallery of Art/ Smithsonian Institution Press, 1989), 58.

16 *Nature and Culture*, 87.

17 Samuel Monk, *The Sublime: A Study of Critical Theories in XVIII-Century England* (Ann Arbor: U of Michigan Press, 1960), 35.

18 Anne Hyde, *An American Vision: Far Western Landscape and National Culture, 1820-1920* (New York: NYU Press, 1990), 14 (hereafter cited as *An American Vision*).

19 Thomas Cole, "Essay on American Scenery" in John W. McCoubrey, ed., *American Art, 1700-1960: Sources and Documents* (Englewood Cliffs: Prentice-Hall, 1965), 101, 105.

20 *An American Vision*, 21.

21 *An American Vision*, 48.

22 "'Wondrously Full of Invention': The Western Landscapes of Albert Bierstadt," in *Albert Bierstadt: Art and Enterprise*, 77, 84, 85.

23 On this point and the relation between Adams and contemporary photography, see my essay "Contemporary Photography and the Myth of the West," in Rob Kroes, ed., *The American West as Seen By Europeans and Americans* (Amsterdam: Free U.P., 1989), 297-325.

24 Peter Wright and John Armor, *The Mural Project* (Santa Barbara: Reverie Press, 1989), *viii*.

25 For the screens, see *An Autobiography*, 187-189, where Adams discusses murals and screens and quotes from his article "Photo-Murals," *U.S. Camera Magazine*, vol. 1, no. 12 (November 1940), 52-3, 61-2, 71-2. *Fresh Snow, Yosemite National Park*, is reproduced in Adams, *The Print*, 181; *Branches in Snow,Yosemite National Park*, in *An Autobiography*, 189; *Leaves, Mills College, Oakland, California*, the image used for the Ickes screen, in *An Autobiography*, 131; and *Half Dome, Orchard, Winter, Yosemite National Park*, the image used for the Curry Company Office Screen, in *An Autobiography*, 188. John Sexton told me at the Adams conference that he saw a work print of *Moonrise, Hernandez* marked off with what he took to be the divisions for making a multi-panel screen, but that he believes no such screen was ever made. The negative has the kind of dots Adams used to mark section divisions in his screens. See the caption below the pictures of wheels in "Photo-Murals," 52. Sexton also said there were "piles" of "giant" prints around when he worked for Adams, and that many were taken out and destroyed.

26 "Photo-Murals," 52.

27 Lincoln Kirstein and Julien Levy, *Murals by American Painters and Photographers*, exhibition catalogue (New York: Museum of Modern Art, 1932); Nancy Newhall, commenting on the San Diego murals, wrote, "Photo-murals were a craze of the day; banks, corporations, travel bureaus, and so forth were ordering huge blow ups and montages with which to paper their walls" (Nancy Newhall, *Ansel Adams: The Eloquent Light* [New York: Aperture, 1963], 121).

28 On billboards, see James Fraser, *The American Billboard: 100 Years* (New York: Harry N. Abrams, 1991). Fraser notes, "The dominant design trend in billboards during the 1950s was the growing use of photography" (107).

29 *American Landscape Painting*, 86.

30 David Robertson, *West of Eden: A History of the Art and Literature of Yosemite* (Yosemite Natural History Association and Wilderness Press, 1984), 131.

31 *Letters*, 143, his emphasis.

32 *An American Vision*, 18.

33 Conversation with the author at the Ansel Adams Scholars Conference.

34 *Letters*, 272-3.

35 *Letters*, 309.

Figure 7 *Popular Photography*, May 1939, vol. 4, no. 5, pp. 14-15.

Figure 8 *Popular Photography*, Feb. 1941, vol. 8, no. 2, pp. 31-35.

Despite being conventional and conservative, American camera clubs of the 1930s and 40s served to initiate photographers into a seemingly contrary realm of personally expressive photography. Examining the influence that Ansel Adams had on Harry Callahan at a workshop for amateur photographers held in Detroit in 1941 will help explain how this was possible.[1] By probing the context and consequences of that workshop, this essay explores the ongoing exchange between the "high art" tradition of American purist photography— of Adams, Stieglitz and Weston—and the vernacular tradition of camera clubs and snapshot photography.

Harry Callahan fell in love with photography when he bought his first camera in 1938. He experimented voraciously but soon exhausted his initial enthusiasm. Callahan needed direction, but where was he to turn, and what model would he follow, as he sought to expand photography beyond mere pointing and shooting? The son of a skilled machine-tool maker at Ford Motors in Detroit and himself a clerk at the Chrysler Corporation, Callahan had nothing in his background that would suggest becoming an artist. Instead, he joined a local camera club, as did thousands of other Americans who had acquired cameras after the Depression and wanted to turn photography into a hobby. Camera clubs called for personal expression in their rhetoric, but in practice they discouraged it. Their members won guaranteed pleasure and satisfaction by forswearing spontaneous personal expression for strict adherence to conventions and formulas, which would insure success in print competitions and juried salons. Camera clubs and photography magazines encouraged amateurs to abandon simple snapshot photography for more carefully structured "pictures." Callahan loathed this aspect of camera clubs, especially the "S-curve" and other compositional formulas that were intended to help amateurs win club contests (figures 7, 8). Callahan had no interest in competition; if he had, he has said, he would have tried to parlay his excellent amateur golf game into professional status.

Nevertheless, Callahan was able to take from camera clubs several basic principles that

shaped his direction as a photographer. In the process of making photography into a hobby, camera clubs put an artistic gloss on the medium, nurturing an alternative to journalistic and documentary photography until museums and art schools took up this role in the later 1940s and the 50s. Even though camera clubs tended to be conservative, their opposition to the documentary and journalistic styles that dominated photography of the 1930s and 40s made them inadvertent repositories of many of the same concerns that marked American purist photography; at the two camera clubs he joined, Callahan learned to appreciate original fine prints of non-utilitarian photographs at a time when the more obvious career route for an ambitious young photographer was to make journalistic and documentary photographs that would have wide circulation as half-tone reproductions.

Callahan first found an alternative to the clubs' formulaic approach to photography through the Detroit photographer Arthur Siegel, who had studied at the New Bauhaus in Chicago and learned from the Hungarian-born artist and teacher László Moholy-Nagy a Modernist approach to photography predicated on the expressive use of formal and technical experimentation. Upon returning to Detroit, Siegel waged an aggressive campaign for Modernism among the mostly conservative camera clubs. In early 1941, Siegel exhorted the members of the Chrysler Camera Club to adopt a freely experimental approach to photography. He urged his listeners, Callahan among them, to quit trying to achieve "artistic" effects by using highly textured, matte papers. He asked them to take up instead glossy paper, which would allow the rich description of texture and tone that Modernists considered a distinctive property of photography. Callahan responded by switching to glossy paper and by making a close-up picture (now lost) of a glass ashtray.

But the real impetus that Callahan says freed him of the constraints imposed by his camera clubs occurred only at the end of the summer of 1941, when Ansel Adams came to Detroit to conduct a workshop for the Miniature Camera Club at Siegel's invitation. In accepting this invitation, Adams showed a willingness, similar to Siegel's, to work with amateurs as part of a broader desire to reform American photography. Adams himself had initially been an amateur photographer; even after abandoning a career in music for one in photography, he kept one foot within the amateur movement, writing letters constantly to *Camera Craft*, *Minicam*, and other photography magazines.

When Adams told Beaumont Newhall, director of photography at The Museum of Modern Art, of the invitation to lead a workshop in Detroit, Newhall was pleased: "It is splendid that the Detroit Miniature Camera Club wants you to teach them, and that they are ready to pay all your expenses. This seems to me an extraordinary thing for a camera club to do, and it gives me confidence in the work which we are doing."[2] This "work" was the attempt to modernize and reform American photography that Newhall, Adams, and the photography collector David McAlpin began when they founded MoMA's photography department in 1940. The department would not passively observe the photographic scene but, as Siegel was doing in Detroit, would encourage amateurs, among others, to embrace Modernism.

The Detroit workshop was held over two weekends, August 22—September 1, 1941. On the Friday that Adams arrived, the club sponsored a reception for 150 people, followed by an after-dinner lecture. On Saturday and Sunday of that and the following weekend the forty photographers enrolled in the workshop participated in field trips and darkroom sessions with Adams. The first Monday, Adams "sat in judgment of individual members' prints."[3]

One participant, Don Shapero, remembers Adams as a "merciless" critic.[4] Of Shapero's pictures, printed on warm-toned matte paper and showing indigenous people in the West Indies, Adams said: "I can excuse reportage but the color is quite stinko." Shapero remembers that Callahan showed no work to Adams, which he says might have been a good strategy, because Shapero felt the workshop set his own work back ten years. Nonetheless, Adams' presence seemed to light a fire under these photographers. On top of the strenuous schedule of the workshop, Callahan went out each night with Shapero and Todd Webb, talking over the day's activities until three or four in the morning.[5]

Adams' method of instruction at the workshop was a blend of demonstration and talk. He stressed both technique and aesthetics, but one member of the workshop remembers that Callahan was intrigued most by Adams' technique.[6] Callahan himself said of the workshop in a 1977 interview: "I took a notebook and I asked [Adams] every technical question I could think of: the kind of paper he used, the lenses he used, the developers and film. Everything. And that was my bible for at least a year."[7]

For Adams, an immaculate technique was essential to the clarity that he demanded in photographs. As a member of Group $f/64$ during the 1930s, Adams opposed the pictorial results camera club photographers sought to obtain by optical, chemical, and manual means, and advocated the creation of straight, unmanipulated photographs, made physically beautiful (and referentially exact) by absolute perfection of technique. Siegel later pointed out that when Adams came to Detroit his reputation was as a leader and teacher of technique, having created his 1935 guide book *Making a Photograph* to give amateurs technical information that was previously privy only to professional photographers.[8]

At the Detroit workshop Callahan not only heard Adams talk about print quality; he also saw Adams' prints at the lectures and on display at the Detroit Camera Shop. The only specific pictures Callahan remembers seeing were the five that constitute Adams' *Surf Sequence, San Mateo County Coast, California* of 1940 (plate 12), which struck him as being very different from what he was seeing in the camera clubs. Not only were the images sequenced, but they were small, sharp, and full toned. In comparison to the mammoth 14 by 17 or 16 by 20 inch prints that dominated photographic salons of the early 1940s, the prints Adams showed in Detroit were mostly 8 by 10 inches or smaller.[9] The small size of Adams' prints was a product of his demand for technical perfection. As a photographic negative is enlarged, its grain pattern becomes more pronounced. Pictorialist photographers accepted, and sometimes desired this transformation; the grain became a screen that came to dominate the texture of the photographed objects and unified the photograph. But Adams, eschewing such deviation from the truthful rendering of textures and tones of the visual world, made modest-sized prints, with little or no enlarging.

Callahan recalls vividly that Adams talked throughout the workshop, returning always to the topics of Alfred Stieglitz, music and the importance of technical perfection and print quality. Adams admired Stieglitz as an artist and as a leader in the photographic community.[10] Not only was Stieglitz the unqualified champion of the "fine" photography that Adams pursued, but the two men held in common a romantic drive to express individual genius through technical perfection. Adams may have also emphasized music at the workshop because the connection of art and music had deep personal roots in his own life. From his background in music, Adams extracted metaphors to explain photography and the photographic process. In associating music with visual art in his workshop

presentations, Adams may have touched on the only significant aesthetic experience in Callahan's background: his mother's piano playing and his father's collection of Caruso recordings. It may have been this connection with his past that unleashed Callahan, allowing him to connect art with emotion and photography with deeply felt experience, rather than with the limited thinking of the camera clubs.

It is clear that Adams fired up Callahan's imagination. Using terms that might character-ize a religious conversion, Callahan has repeatedly said that Adams set him free, releasing him from the camera clubs' formulaic approach to subject matter, composition and technique. Adams himself disdained the "dismal monotony" of salon exhibitions, which he blamed on the "offer of rewards for a photographer's ability to conform rather that for what he says in his picture."[11] Adams offered Callahan a radically different conception of photography. More than just improved technique, he was suggesting a whole changed way of being that would result in a different type of picture. Adams insisted that Callahan learn to take himself, rather than the rules and juries, as the arbiter of quality, that he learn to "look with perceptive eyes at the world about [him], and trust to [his] own reactions and convictions," with the result that he could practice photography as a personally expressive art that revealed spirit and character.[12]

Callahan learned this lesson. In addition, his cultivation of feelings and instincts extended beyond things directly photographic. For the first time in his life, he listened to classical music and went to art museums: "I had entered the art world and was listening to music."[13] Callahan was "nuts about music," with a taste that ran towards the modern, preferring Stravinsky and *The Rite of Spring* to Bach.[14] Under Adams' influence Callahan started collecting records. Even though he had little money, he would scour record shops to acquire new albums as they came in, building a collection that soon filled several packing cases.

Following the workshop, Callahan worked like a demon. This and other effects of Adams on Callahan were noted in January 1942 when Callahan was nominated to the Hall of Fame sponsored by the Photographic Guild of Detroit.[15] The nomination noted an important technical change in Callahan's photography. Before Adams' visit, Callahan had enlarged his negatives from both his Rolleicord and his Linhof cameras with his 4 by 5 inch Omega D-2 enlarger. After the workshop Callahan quit enlarging his negatives and began making only contact prints. In this way he could achieve the kind of textures and tones he had seen in the prints Adams had shown in Detroit. Seeing that Callahan preferred contact prints to enlargements, his friend Shapero got him to swap his Omega enlarger for an 8 by 10 inch Deardorff view camera, which produced large negatives and equally large contact prints. Following this exchange, which had occurred by December 1941, Callahan photographed only with the two view cameras, and in further emulation of Adams, printed the negatives only on Kodak No. 2 paper.[16]

The Detroit Hall of Fame nomination also recognized that Callahan was developing something most camera club members lacked—an individual style. Callahan had taken from Adams the will to have a personal style, but he also took from him the foundations that would become his style. Adams reinforced Siegel's encouragement that Callahan should use glossy paper to achieve sharp focus, full-toned images. More importantly, Adams led Callahan to make photographs of very ordinary bits of the natural world. The example of the *Surf Sequence* and other similarly flat images by Adams further moved Callahan to construct his pictures with flat planes parallel to and closely behind the picture's

surface. Such shallow, limited space was markedly artificial, and served to distinguish pictures by Adams and Callahan from those made by photographers with more realist, or documentary, intentions. Such flatness reinforced these picture's status as personally expressive statements, marking them as art and as "modern."

A decade before the Detroit workshop, Adams had become a modern photographer under the influence of Paul Strand, who first showed him the potential of the medium as an expressive art, and of Stieglitz, who introduced him to the idea that a photograph could be creative to the extent that it was made as the "equivalent" of what the maker saw and felt. As a result of these influences, Adams quit making the picturesque landscapes of the American West that had occupied him in the 1920s (but which would occupy him again, beginning with a burst of wartime patriotism in 1943-44). A year before the workshop, Adams was still interested in equivalency.[17] At the same time he connected equivalency with the use of details, recognizing that one need not take in an entire scene in order to be expressive. He noted that there "is something very satisfying about the thought that within ten feet of you at any given time lies enough material to keep you busy a lifetime learning to understand it."[18] Adams' *Grass and Water, Toulumne Meadows, Yosemite National Park* (plate 10), made within this ten-foot-range, shows a very simple place, not the picturesque grandeur of mountains or the idyllic beauty of open meadows. Callahan says he was especially influenced by what he calls Adams' pictures "made along the ground," a category that could certainly include this picture.[19]

Under the influence of such pictures by Adams, Callahan made during the next winter pictures of subjects on the fringe of everyday experience, depicted clearly and straightforwardly. Just as Callahan rejected Pictorialism, he was by nature unwilling to follow Adams slavishly. While he has credited Adams with setting him free of Pictorialist rules so that he could trust himself, and with teaching him to appreciate the aesthetic value of a technique that would fully render the most subtle details of the surrounding world, Callahan remained ambivalent about Adams. In terms of subject and scale, Callahan never fully embraced Adams. As he said later: "Ansel's thinking wasn't so much what I liked; it was just that he hit me at just the right time."[20]

During the winter of 1942-43 Callahan began work that challenged what he had learned from Adams about fidelity to tone and texture. He was suddenly drawn to the expressive power of abstraction and technical experimentation. "I was photographing weeds in snow," he said later. "I looked through the camera and I just saw the lines. That was a really exciting and beautiful thing to me."[21] In the photograph that resulted, *Weeds in Snow* (plate 11), weeds form an abstract pattern against snow, which appears as an undifferentiated field of white. Callahan's use of high contrast in this picture shows his rejection of Adams' demand that photographs render a full range of tones. Callahan made this picture in direct contradiction to the technical advice Adams had given at the workshop, as he has explained: "Somebody might say, how do you get good snow texture and Adams would say, you use a G filter, or something like that. But the point was he was concerned with some kind of reality, so it looked like snow. He wanted everything to look like it looked to your eyes. So it was a real adventure to me to distort it."[22] According to Callahan, when Adams first saw *Weeds in Snow* he thought it was an abstraction. He said to Callahan, "Why don't you do something real?" After Siegel explained to Adams that this *was* something real, Adams asked Callahan to sell him a print of the picture.[23]

But even as Callahan rejected the call for the full rendering of tones, other aspects of Adams' photography began to affect Callahan. Probably also in the winter of 1942-3, Callahan began to experiment with another new motif. He later said of this new direction: "I had sort of run out of gas and didn't know what to do next so I started making a series of three. The idea of change really fascinated me—to keep the camera in the exact spot and just put in another sheet of film to show the changes."[24] Callahan shot what he remembers as hundreds of exposures of a long flight of concrete steps that connected the town center of Highland Park, Michigan, to a bus stop on a depressed expressway that cut through town. Successive images, made with no change in the camera's position, compose a musical fugue, as human figures mass and re-mass against pale concrete.

When Callahan made this *Highland Park* series (plate 13), he had heard from Adams about Stieglitz's serial cloud pictures (and had tried without success to see them at Stieglitz's gallery in New York). He had also seen Adams' own *Surf Sequence, San Mateo County, California* (plate 12), which was comprised of five photographs made from a single point with no re-aiming or refocusing of the camera. About this work, Callahan later said: "Ansel's wave sequence influenced me the most [of what I saw of his work at the workshop]. I later forgot all about that sequence and started doing series myself —I thought I was doing something original...Of course, I had gotten it from Ansel."[25]

Callahan's practice of constant change in his photography and his penchant for returning repeatedly to previously explored subjects and techniques defies any simple model of influence. Hence, Adams was for Callahan a resource from which to draw throughout his career. Despite his exposure to the Constructivism of Moholy-Nagy of the Institute of Design, he never abandoned Adams' notion that careful seeing was essential to individual expression. In the early 1950s, feeling his students were excessively dominated by the Bauhaus, Callahan introduced assignments that stressed seeing over technical experimentation. Similarly, in his own work from around 1950, vision began to predominate over experimentation. In 1957, during a year in southern France, Callahan returned to nature and the landscape, a subject first explored at the time of the Adams workshop and then abandoned.

The lifelong influence that Adams has had on Callahan is a testament to the vitality of the 1941 interchange that occurred between these two important American photographers and the fecund and open exchange that was then possible between the realms of art and amateur photography. Callahan, as an amateur, was involved in the only game in town for taking photography seriously. Because of this, Adams earnestly concerned himself with the cultivation of amateur photographers. To dismiss as total backwaters the American camera clubs of the 1930s and 40s is to miss the original context that produced the photography that emerged in those decades.

For help in the preparation of this essay I am grateful to Joe Munroe, Don Shapero, and Todd Webb, for reminiscences and documentation about Detroit camera clubs; Jim McQuaid, for sharing his research on Detroit amateur photography; Amy Rule, for help with research in the archives of the Center for Creative Photography at the University of Arizona; and Susan Earle and Chris Miele, for editorial comments. Finally, I would like to thank Harry Callahan for providing the raw materials for exploring his life and work.

NOTES

[1] I have previously discussed the relationship of Adams and Callahan in John Pultz, *Harry Callahan: Early Street Photography, 1943-1945*, The Archive Research Series, no. 28 (Tucson: Center for Creative Photography, University of Arizona, 1990); parts of this essay first appeared there in a slightly different form.

[2] Beaumont Newhall to Adams, 22 July 1941, Beaumont and Nancy Newhall Archive, at the Center for Creative Photography, University of Arizona (hereafter cited as CCP/UA).

[3] "Ansel Adams 'Wows' Detroit: Wizard of Yosemite Spends Eight Days Here," *The Bulletin* (Miniature Camera Club of Detroit), vol.3, no.1, September 1941, 2.

[4] Don Shapero, telephone conversation with the author, 4 November 1989.

[5] Harry Callahan, interview with the author, New York City, 29 April 1990.

[6] Joe Munroe, telephone conversation with the author, 4 November 1989.

[7] Callahan, interview with Harold Jones and Terence Pitts, February 1977, at CCP/UA, published as "Harry Callahan: A Life in Photography," in Keith Davis, ed., *Harry Callahan Photographs: An Exhibition from the Hallmark Photographic Collection* (Kansas City, Missouri: Hallmark Cards, Inc., 1981), 51.

[8] Arthur Siegel, interview with James McQuaid, assisted by Elaine King, 29 October - 6 November 1977, transcript list 3, lines 1090-1102. Conducted in Chicago as part of the International Museum of Photography/George Eastman House Oral History Project.

[9] On the large size of salon prints, see Christian Peterson, *Pictorialism in America: The Minneapolis Salon of Photography, 1932-1946* (Minneapolis: The Minneapolis Institute of Arts, 1983), 41. In a March 1989 interview with the author, Callahan recalled that among Adams' photographs he saw at the workshop, at most two were 11 by 14 prints, with the rest divided equally between 8 by 10s and smaller prints (5 by 7 or 4 by 5). Elsewhere (Davis, ed., 51) Callahan says there were no prints as large as 11 by 14 inches.

[10] Several months before the Detroit workshop, Adams tried to express these sentiments to Stieglitz in a letter written after a visit the two men had had in New York: "It's no use for me to try to tell you about what you and [An American] Place signify to me; I can best tell you by making some kind of photograph that you might like" (Adams to Stieglitz, 8 June 1941, Adams Archive, CCP/UA, reprinted in Mary Street Alinder and Andrea Gray Stillman, eds., foreword by Wallace Stegner, *Ansel Adams: Letters and Images 1916-1984* [Boston: Little, Brown and Company, 1988], 131).

[11] Jacob Deschin, "For Better Pictures: Ansel Adams' Program of Improving Photography," *New York Times*, 12 December 1948, sec. 2: 15, paraphrases comments by Adams in the 1949 edition of the *Annual of the Photographic Society of America*.

[12] Deschin, sec. 2:15, quotes Adams.

[13] Callahan, interview with the author, Atlanta, 9-12 March 1989.

[14] Ross Haarz, telephone conversation with the author, 27 November 1989. Haarz, a co-worker of Callahan's at GM, characterized Callahan's musical taste on the basis of his selections for the radio in the darkroom they shared, in 1944, at General Motors Photographic Division.

[15] "We Open Our Own Private Hall of Fame," *Bulletin of the Photographic Guild of Detroit*, vol. 3, no. 4, January 1942, 3. With this issue, *The Bulletin* took on a longer name that incorporated the new name of Callahan's camera club.

[16] Kodak photographic paper comes in five grades of contrast, going from No. 1, with the least contrast, to No. 5, with the greatest contrast. By sticking to a single grade of paper, Callahan was denying himself the opportunity to match the paper to the contrast of the negative he was printing and the finished product he desired.

[17] Adams described it at length in a letter: Equivalents were not "*interpretations* of things, or predetermined convictions about things," he explained 1940, but "represented moods—they were *equivalent* to something felt deep within" (Adams to Wright, 13 July 1940, in Alinder and Stillman, eds., 117).

[18] Adams to Wright, in Alinder and Stillman, eds., 117.

[19] Callahan, interview with the author, New York City, 17-18 September 1991.

[20] Callahan, interview with the author, New York City, 20 January 1990.

[21] Davis, ed., *Harry Callahan Photographs,* 54.

[22] Callahan, interview with the author, New York City, 20 January 1990.

[23] Callahan, interview with the author, Atlanta, 9-12 March 1989. The print Adams acquired is now in the Ansel Adams Collection at the CCP/UA. Callahan never sent a bill, he says. Amy Rule has located a letter dated 18 August 1958, in which Callahan acknowledges receiving from Adams $100 for 2 prints, which she suggests may be for this and the one other work by Callahan that are in the Adams collection.

[24] Davis, ed., 51.

[25] Davis, ed., 51.

Figure 9 ANSEL ADAMS, *Dorothea Lange, Berkeley, California*, 1965.

Sandra S. Phillips

ANSEL ADAMS AND DOROTHEA LANGE: A FRIENDSHIP OF DIFFERENCES

Dorothea Lange and Ansel Adams were both photographers of tremendous gifts, passion and commitment. Although they were poles apart in temperament and in aesthetic ideals, they learned from each other and, indeed, needed each other (though both would surely be loathe to admit it). They knew each other well, were neighbors for much of their professional lives, and friends of varying degrees of intimacy from the 1920s, when Lange operated a portrait studio in San Francisco, until her death in 1965. In 1963, on her way to follow her husband Paul Taylor to Egypt, Lange wrote Adams: "I have no business to stop *all* of this, to sit down with a bum pen and scratchy paper to write you a letter. The reason is that silence between you and me can last just *so* long, and then I feel I need to reach out toward you and say Hello, are you there? Is all well with you....Are you still worshipping the same Gods of Beauty and Truth?"[1]

Adams first knew of Lange in the 1920s, when she worked as a portrait photographer in San Francisco. She was consistently much more modest than Adams about her ambitions, and early on was insistent about describing her profession as "a craft"—it was clear to her that she was not an "art" photographer. What she later said of her many years as a portrait photographer reveals a general attitude towards her work in relation to her contemporaries: "People like Imogen Cunningham, whom I knew very well by that time, all worked for name and prestige, and sent to exhibits. But I was a tradesman. At least I so regarded myself. And I was a professional photographer who had a product that was more honest, more truthful, and in some ways more charming."[2]

This attitude, as well as the kind of work she was making, probably excluded her from Group *f*/64 , which Ansel Adams and other artistically inclined California photographers started in 1932. Lange, no doubt, saw *f*/64 as being excessively concerned with "the Gods of Beauty and Truth," but the group's existence also probably helped her to clarify her own gifts. In contrast to *f*/64's devotion to "pure" photography, Lange chose to become the

Figure 10 DOROTHEA LANGE, *The General Strike (Policeman), San Francisco*, 1934.

innovative documentarian. Adams, as one of the founders of *f*/64, was very interested in the use of photography for personal expression, while Lange took more of an objective tradesman's approach. Indeed, from its beginning her photographs of people are naturally, not artfully, posed and are generally more psychologically complex than those by Adams and her other contemporaries in *f*/64 (plates 14 and 15).

When the Group *f*/64 photographers became organized in the fall of 1932, and planned their first major statement in a museum show at the de Young Museum, Adams declared that they represented a group of workers "who are striving to define photography as an art form by a simple and direct presentation through purely photographic methods."[3] The

group, which officially included Adams, Edward Weston, Imogen Cunningham, John Paul Edwards, Sonia Noskowiak, Willard Van Dyke and Henry Swift, never did invite Lange to be a member, it seems, although she participated in at least one of their exhibitions.[4] But by the time their major show opened at the de Young, she had already sent out a modest notice to her portrait customers, which declared: "Pictures of People, Season of 1932-33, Dorothea Lange, Photographer, 802 Montgomery Street." Maynard Dixon, her husband at the time, entered into his diary the following passage: "Dorothea begins work on the Forgotten Man." FDR had just won the election. The Depression was in its third year.

What became a clear distinction between Lange's photographs and those of the f/64 group members was its currency. In a Lange photograph, not only is the depicted event of human significance, but there is also evidence of the real moment in which it was seen—not the immutable timelessness of the art-oriented pictures. By 1933, the social realities of northern California were becoming difficult to ignore, and events would accelerate. In early 1933, Dorothea walked out of her Montgomery Street studio to photograph the White Angel bread line, making a portrait outside the studio confines which she had no hope of selling.[5] The following May she photographed a Communist May Day rally in the city, and later the San Francisco Maritime Strike (figure 10), which escalated into a general strike when the governor called in the National Guard. It was at this time that Willard Van Dyke, a young photographer, friend of Edward Weston and member of f/64, offered to show her work at his Oakland gallery.

For Adams, the early 1930s was a time when his ideal of what art photography should be was intensified and confirmed. In February, 1933 Adams and his wife Virginia left for a trip to New York before the birth of their first child, Michael. There he had his first portentous meeting with Stieglitz, who told the younger man that his pictures were "some of the finest photographs I've ever seen."[6]

During this visit, Adams was also offered a show at Alma Reed's Delphic Studios, a gallery which showed Edward Weston and the Mexican muralists. The work he would show there in 1933 and later at Stieglitz's gallery An American Place in 1936 was closely related not only to the work of his colleagues in f/64, but also to the ideals of abstraction and technical purity that he shared with contemporary photographers in the East, who were affected by cubism. He was also, even at this relatively early moment, certain of the spiritually renewing power to be found in nature. Although there is occasionally an awareness of current events in his photography, it is more allied to the rediscovery of American subjects found at An American Place or in the work of the more belligerent conservative painters of the 1930s such as Thomas Hart Benton and Grant Wood.

In the summer of 1934, when Willard Van Dyke opened his exhibition of Dorothea Lange's work at his gallery, the complexion of American photography in California was in transformation. Many photographers, including several charter members of f/64, had become responsive to what Paul Taylor, an activist economics professor at Berkeley and future husband of Lange, called "the social effects of the Depression."[7] Van Dyke, who had played a pivotal role in the formation and articulation of f/64, summed up his own feelings in a statement he made later about Edward Weston's influence on his own work:

When I saw [Weston's] work in 1928, although I had already been photographing for several years, I knew that there was a path I had not perceived before....At first I

followed his way, but too slavishly. Then I began to become aware of the problems
of the immediate world around me. Of soup lines and men and women out of work....I
began to be fascinated by the abandoned storefronts, just as much as I had been by
the clean forms of a ship's funnels or the sensuous curves of a sand dune."[8]

Although he had helped to form *f*/64, Van Dyke was beginning to question the formal "revolution" that the group championed. And as a result of his newly-found friendship with Dorothea Lange, he began to turn toward a photography of social conscience.

Van Dyke encouraged Paul Taylor to invite some of his like-minded friends to accompany him into the field to observe firsthand manifestations of social problems that Taylor was studying. Through Van Dyke, Taylor invited Imogen Cunningham, Preston Holder, Mary Jeannette Edwards and Dorothea Lange to see one of the self-help cooperatives that had been engendered by unemployment—in this case, in Oroville.[9] This was the first time Lange and Taylor met and she was impressed not only by his presence, but by his analytic methods. Interestingly, all of the photographers with the exception of Lange were members of *f*/64 or had strong ties to it. One of Lange's pictures made on the trip constitutes her first use of an extended explanatory caption under a photograph, although not attributed in this early instance. Under a closeup of a man in a tree: *A carpenter thins apricots. Mexicans in the same orchard thinned two trees to his one. A waste of skilled labor.*

In a letter to Stieglitz dated May 20, 1934 Adams acknowledges his own attitude toward the political complexity of the times:

> *I am getting dreadfully tired of being used as a tool for radical interests—artists in the*
> *main are asked to do "Proletarian" work, photographers are asked to photograph*
> *May Day celebrations, old human derelicts in a dingy doorway, evictions, under-paid*
> *workers, etc. etc. I grant that the times are portentous, but I'll be damned if I see any*
> *real rightness of being expected to mix political economy and emotion for a purpose.*
> *I am ready at any time to offer my services to any constructive government —Right*
> *or Left, but I do not like being expected to produce propaganda. Half my friends here*
> *have gone frantic Red and the other half have gone frantic NRA."*[10]

Although Adams, like Weston, felt it necessary to remain aloof from the tumultuous politics of the period, he was certainly convinced of the historical importance of social documentary photography. In 1933 he applied for a Guggenheim grant just as his show was being presented at the Delphic Studios. He proposed two different projects: "A Photographic Record of the 'Pioneer' Architecture of the Pacific Coast (California and Nevada Mining Towns Coast Range Farm Architecture, etc., as distinct from the 'Spanish' derivations)," and "Research in Contemporary Photography (chiefly American)." The latter proposal was divided into three sections: "a) The status of modern photography as an aesthetic expression, b) Present documentary photography as an instrument of social research, and c) News, Advertising and Scientific Photography."[11] Adams made clear in the project description that he was very aware of the socially significant role of photography, and, as he stated in his proposal, of the importance of Walker Evans and Dorothea Lange

In an unpublished statement from the same period, Adams was enthusiastic about Lange's subsequent work:

> *An extraordinary phenomena in photography. She is both a humanitarian and an*
> *artist. Her pictures of people show an uncanny perception, psychological and*

emotional, which is transmitted with immense impact on the spectator. To my mind, she presents the almost perfect balance between artist and human being. I am frankly critical of her technique in reference to the standards of purist photography, but I have nothing but admiration for the more important things—perception and intention. Her pictures are both records of actuality and exquisitely sensitive emotional documents....There is never propaganda....If any documents of this turbulent age are justified to endure, the photographs of Dorothea Lange shall, most certainly.[12]

Out of the studio for good now, Lange was learning to clarify and expand her perceptions. In contrast to the sensibilities of the *f/64* group, she was not attempting to make photographs that were timeless, but rather specific to a time, place and condition. Following Taylor's example, she began to interview her subjects in order to enlarge the scope of the pictures and to aid in sequencing. The work she was making was more at home in reports and books than exhibited or treasured as objects of contemplation. Adams, writing a series on photography for *Camera Craft*, noted that the danger of this new form of photography was in its potential to become "a tool of obvious propaganda."[13] Nevertheless, when Adams' book *Making a Photograph* came out in April 1935, it included a beautifully reproduced image of Lange's photograph *White Angel Bread Line,* the only picture in the book not by Adams. He was excited enough by the reproduction—its quality as well as its being a subjective picture so dissimilar to his own aesthetic viewpoint—to point it out specifically in a letter to Stieglitz.[14]

In 1934, Lange began to collaborate in earnest with Paul Taylor. No doubt aware of this development, Adams wrote a letter to an anguished Edward Weston, who was worried about languishing unnoticed (and underfed) in Carmel. He suggested that Weston continue to live in Carmel, noting that neither of them were comfortable with metropolitan life. Then he said:

Both you and I are incapable of devoting ourselves to contemporary social significances in our work; Willard is gifted in this respect. I come to think of him more as a sociologist than a photographer....I still believe there is a real social significance in a rock—a more important significance therein than a line of unemployed. For that opinion I am charged with inhumanity, unawareness—I am dead, through, finished, a social "liability;" one who will be liquidated when the "great day" comes.

You and I differ considerably in our theory of approach, but our objective is about the same—to express with our cameras what cannot be expressed in other ways—to trust our intuition in respect to what is beautiful and significant—to believe that humanity needs the purely aesthetic just as much as it needs the purely material.

Stieglitz has dynamically maintained this point of view. Your shells will be remembered long after Evans' picture of two destitutes in a doorway. Dorothea Lange strikes the middle road—she takes contemporary material and always sees it emotionally—there is always something beyond the subject in her things.[15]

The pressure to create "socially relevant" work did not go away. By the time Lange entered into regular work for the Resettlement Administration in September 1935, Adams would be called upon to help her with developing negatives and making enlargements, and was in this very direct way aware of her ongoing work. They would both be very concerned about political issues, and both would respond in entirely characteristic ways. He was frank about his confusion in a 1936 letter to Willard Van Dyke in New York:

> *I have wanted to write to you or talk to you seriously about my interpretation of your tendencies and about whatever tendencies I have myself towards a social rehabilitation.*
>
> *I am anxious to advise you that I am really miserably impatient and worried over the conditions of contemporary life. I grant the basic logic of the Marxian doctrineHowever, my training has been introspective and intensely lonely. I have been trained with the dominating thought of art as something almost religious in quality. In fact, it has been the only faith I have known....However, for quite a few years I have been fully aware of the fact that something was missing—something of supreme importance. The "contact with life" you may call it. It has been apparent to me that there is no way out in a system such as ours, but I have been unable to visualize within my mind an acceptable alternative.*[16]

Perhaps the most outspoken anger by Adams over political differences was expressed in 1938, in regard to the proposed publication of a book to be called *Five American Photographers*. The book, which was never published, was probably going to focus on Adams, Weston, Van Dyke, Lange, and possibly Homer Page. The preface, which remains undiscovered, was written by Ben Maddow, a relatively recent arrival to Southern California from New York, where he had been friendly with the leftist *Partisan Review* intellectuals.[17] His essay inflamed both Weston and Adams. Adams wrote to Weston:

> *The trouble with us, Edward, is that we are narrow—we are dead—We don't know what is going on (and we don't give much of a damn about it anyway). But I would rather have one dead Weston than 1,000 alive Dialectic Goose-Steppers. I think Dorothea has done a swell job with the Labor subject—but she photographs a lot and talks very little. Those guys in New York talk a Hell of a lot and photograph very little."*[18]

And later from Weston to Van Dyke:

> *It seems so utterly naive that landscape is not considered of 'social significance' when it has a far more important meaning on the human race of a given locale than excrescences called cities. By landscape I mean every physical aspect of a given region—weather, soil, wild flowers, mountain peaks —and its effect on the psyche and physical appearance of the people..."*[19]

Apparently Maddow, full of Marxist dogma, had described Weston and Adams as old fashioned mystics, not truly contemporaneous as was Lange because of their unwillingness to take on contemporary events in a political framework. Clearly, from all their anger, this criticism hurt.

Just after Pearl Harbor, there existed an intense anxiety in California about the presence of a large Japanese-American population. As a result, all Japanese-American citizens of first, second and third generations living in the mainland United States were "relocated" into concentration camps. It was an entirely racially-motivated directive, and no one was ever specifically charged or found guilty of anything. Lange and Taylor were vociferous in their antagonism. Hired by the War Relocation Authority, she documented the large cultural presence of the Japanese in San Francisco before the internment(figure 11), as well as the tragic process of reporting to government centers and the bleak and sometimes desperate

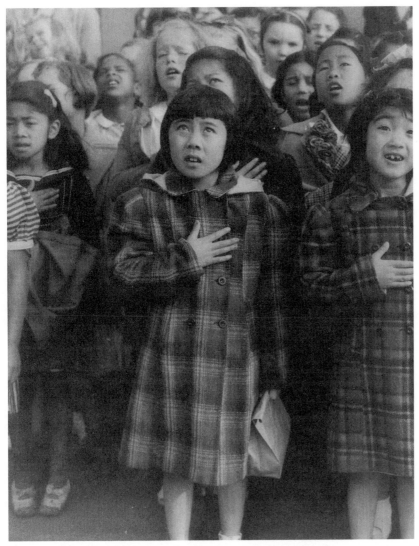

Figure 11 DOROTHEA LANGE, *One Nation Indivisible, San Francisco*, 1942.

conditions the Japanese-Americans had to live with in the internment centers.

Adams was also distressed by the Japanese situation. Friendly with the second director of the internment center at Manzanar, he made a series of pictures there by which he proposed to show the patriotism of the inhabitants of the camp through their conciliatory stance and their determination to make the best of an intrinsically bad and divisive situation (plate 16).

> *I went down to Manzanar and photographed, oh, hundreds of people, and practically everyone was positive. They'd rejected the tragedy because they couldn't do anything about it. The next step was a positive one....Because of this adversity, about which they could do nothing, they became a marvelous group of positive forward-looking people.*"[20]

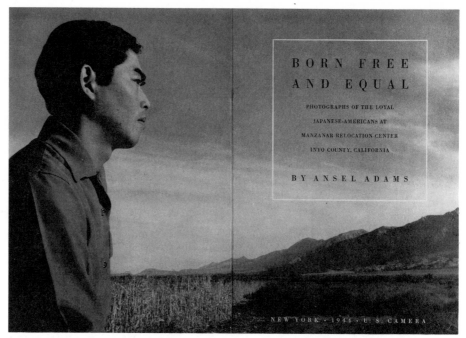

Figure 12 Spread from *Born Free and Equal,* 1944. Photograph by Ansel Adams.

Working in and around the camp, his aim was to show how noble and selfless these Japanese-Americans were, and how they were inspired by the beauty of the surrounding mountains—to Adams, this observation may have validated his feelings about the social significance of nature. One of the photographs that Adams made is one of his most famous: *Mount Williamson, Sierra Nevada, From Manzanar, California* (plate 4). It was Adams' contention that this landscape contributed to the positive attitude that he perceived among the interned—an attitude that, however beneficial, denied the real problems of their situation, and was thus deliberately, and even narrowly positive.[21] Assisted by his friend, Nancy Newhall, the photographs were shown at The Museum of Modern Art and a book entitled *Born Free and Equal* (figure12) was assembled.[22] In contrast to Lange's work, Adams' pictures of this subject are more one-dimensional. They are not psychologically penetrating, and resemble, in a curious way, propaganda. Late in life, Lange expressed disdain for what she felt was a wrongheaded liberalism on Adams' part. When an interviewer asked about the book *Born Free and Equal,* she said:

> *It was shameful. That's Ansel. He doesn't have much sense about these things....He's ignorant in these matters. He isn't acutely aware of social change. It was far for him to go. He felt pretty proud of himself for being such a liberal.*"[23]

The last example of the direct contact between Adams and Lange to be discussed here (not the last they experienced, certainly) was their work in 1944 for an issue of *Fortune* magazine. The photographs that they made for this assignment were presented with articles on the agricultural economy of California and the transformation of the state, particularly in northern California, as its shipbuilding and other war preparedness industries were taking off (figure 13).[24]

The problems of the Depression subsided as the American economy revved up for war, and the migrant laborers who had fled the dustbowl for the "golden state" of California found jobs in Bakersfield and Richmond. Richmond, just north of Berkeley, was especially interesting to Lange, since there she found a true mixture of native Californians, transplanted dustbowl farmers from the midwest known as Okies or Arkies, and poor blacks from the South. While the Richmond assignment was brash and very exciting for Dorothea, to Adams this was more a commercial job. His contributions were some of the long shots that appeared in *Fortune*—distant views of the town—while hers focused on human events of a more personal nature. At one point (although the story is still unclear) they came upon some workers' children, Lange's natural subject matter. She dared Adams to try his hand. The resulting picture, *Trailer Camp Children, Richmond, California*, ca. 1944 (plate 17), was emotionally distant and less compellingly psychological than Lange's work. It was, however, possessed of a very beautiful sense of light—the trademark of Adams' aesthetic personality.[25]

The friendship between Adams and Lange lasted until her death in 1965. For one so ostensibly different in aesthetics and temperament, Adams proved to be an ardent champion of Lange's work and the principles of documentary photography. He was constantly critical of her poor technique and her sloppy printing, but also of her reluctance to consider herself as "a fine artist." In 1962, responding to her desire to make photography a tool for social causes, he wrote to her with some exasperation:

> You happen to be one of the very few who has brought enough deeply felt human
> emotion into your work to make it bearable for me. I wish you would try and think
> of yourself as a fine artist—which you are. That is a damn sight more important to
> the world than being merely an extension of a sociological movement.[26]

Figure 13 Spread from *Fortune*, Feb. 1945. Photograph by Ansel Adams and Dorothea Lange.

Without a doubt, Adams was deeply appreciative of Lange's ability, and although there is no corresponding record of her understanding of him, they often felt comfortable, even complementary, in working together. When she made her move outside the studio to photograph the White Angel bread line early in her career, he was one of the first to appreciate her accomplishment. Knowing her interests so well, and her social commitments, he seems to have wanted to make the Manzanar pictures not only as a contribution to the war effort (he was feeling useless in Yosemite) but to accept the challenges of a political situation. Moreover, Adams had come to realize the limitations of his aesthetic temperament, specifically that he was less successful photographing people than landscapes. As he said to a friend, "The next step will be to correlate the symbolic qualities of the national scene with the people..."[27] But he also clearly stated his divergence from the earlier faith in the "Gods of Beauty and Truth" in 1943 when he wrote: "I believe that the highest function of post-war photography will be to relate the world of nature to the world of man, and man to men."[28]

Adams' awareness of the chasm between his work and that of Lange led to his desire to collaborate with her. This was more than a collaboration between the apolitical and the committed liberal photographer, or the large picture and the more intimate; he was the positive, assertive force, she the questioning, probing one. He was evincing the beneficence of nature without the intrusion of man, she was trying to find some balance between individuals and the real world. His work was in many respects an escape into nature's diverse beauties; she, finding those impulses irrelevant, created work that, in Adams' words, made "contact with life."

Having observed Lange's transformation to social documentation, and Willard Van Dyke's shift from "art" to "politics," Adams' own social conscience had been stirred. During these years—the Depression, the War, and the aftermath of McCarthyism—his certain belief in formalism and his deep regard for what Lange called "Beauty and Truth" was on trial. Through it all, however, his ardent partisanship for the environment was his answer to the pressure exerted upon him to create socially relevant work—this was at least in part inspired by Lange's awareness of the complex relationship of the people she photographed to the larger social forces that surrounded and often overwhelmed them. Just as Lange certainly appreciated his consistent support of her accomplishments as "an artist," so was her badgering insistence on social consciousness valued (though perhaps not *so* clearly articulated) by Adams. They were friendly antagonists—and their friendship and antagonism inspired them both.

The author would like to acknowledge the help she has received from the Lange family, the Partridge family, Therese Heyman, Amy Rule, and William Turnage.

NOTES

1 Dorothea Lange, letter to Ansel Adams, 8 June 1963, Ansel Adams Archive, Center for Creative Photography, University of Arizona, Tucson (hereafter cited as CCP/UA).

2 "Dorothea Lange: The Making of a Documentary Photographer," interview conducted by Suzanne Reiss (Berkeley: Regional Oral History Office, Bancroft Library, University of California, 1968), 92. As she stated about her portrait work, "I wasn't trying to be a great photographer. I never have: I was a photographer and I did everything that I could to make it as good as I could. And good meant to me being useful, filling a need, really pleasing the people for whom I was working" (Milton Meltzer, *Dorothea Lange: A Photographer's Life* [New York: Farrar, Straus, Giroux, 1978], 50).

3 Quoted in Deanna Kastler, *Group f/64*, exhibition brochure (The Fine Arts Museums of San Francisco, 1958), 3.

4 Meltzer, 73. See also "Conversations with Ansel Adams," interview conducted by Ruth Teiser and Catherine Hamonn, with introductions by James L. Enyeart and Richard M. Leonard (Berkeley: Regional Oral History Office, Bancroft Library, University of California, 1978), 101: "Dorothea Lange never quite forgave us for not getting her in the group [f/64]. She at that time was so pictorial and so fuzzy-wuzzy that it never occurred to us. And I really regretted it later after seeing more of her work."

5 Therese Heyman, Curator of Photography at the Oakland Museum, has mentioned that the "White Angel" was a society woman in San Francisco who fed the indigent before Roosevelt's programs were started.

6 Nancy Newhall, *Ansel Adams: The Eloquent Light* (New York: Aperture, 1963), 85.

7 Paul Taylor, interview provided by Meg and Betsy Partridge, Summer 1987.

8 Quoted by Therese Heyman in *Seeing Straight* (on the f/64), exhibition catalogue, (Oakland Museum, Fall 1992), 22. See also Willard Van Dyke's unpublished autobiography, CCP/UA, and his two brief, socially-conscious tracts, of about 1938, entitled "What Art Means to Us" and "What Art Means to Me," in the Van Dyke Archive, also at CCP/UA.

9 Paul S. Taylor and Clark Kerr, "Whither Self-Help," *Survey Graphic*, 23: 328-331, 348. Bancroft Library retains the Oroville project photographs from the Taylor papers.

10 Adams to Alfred Stieglitz in Mary Street Alinder and Andrea Gray Stillman, eds., foreword by Wallace Stegner, *Ansel Adams: Letters and Images 1916-1984* (Boston: Little, Brown and Company, 1988), 70. Adams seems to have suspected Lange to be a Communist during some part of her career. See Ansel Adams with Mary Street Alinder, *Ansel Adams: An Autobiography* (Boston: Little, Brown and Company, 1985), 266. She probably was not (See "Dorothea Lange: The Making of a Documentary Photographer," 150-151).

11 Ansel Adams, Guggenheim application letter, 13 November 1933, from the Ansel Adams Archive, CCP/UA, provided to me courtesy of William Turnage.

12 Newhall, 82.

13 Ansel Adams, "An Exposition of My Photographic Technique," *Camera Craft*, April 1934, 180.

14 Adams to Stieglitz, 16 May 1935, in Alinder and Stillman, eds., 77-9.

15 Adams to Weston, 29 November 1934, Ansel Adams Archive, CCP/UA.

16 Adams to W. Van Dyke, quoted in Van Dyke's unpublished autobiography, provided to me by William Turnage.

17 Maddow acknowledges in a letter to the author that he wrote such a preface. See also a letter from Weston to Van Dyke, 18 April 1938, CCP/UA.

18 Adams to Weston, 16 April 1938, Ansel Adams Archive, CCP/UA. It appears that Van Dyke was a friend of Maddow's.

19 Weston to Van Dyke, 8 April 1938, Van Dyke Archive, CCP/UA.

20 "Conversations with Ansel Adams," 24.

21 See Nancy Newhall's review of *Born Free and Equal* and a description of the exhibition in *Photo Notes*, June 1946, 3-5. Turnage believes that the onesided optimism of Adams' approach was effective.

22 Ansel Adams, *Born Free and Equal* (New York: U.S. Camera, 1944).

23 "Dorothea Lange: The Making of a Documentary Photographer," 190.

24 Dorothea Lange and Ansel Adams, "Detour Through Purgatory," *Fortune*, Pacific Coast issue, vol. 31, no. 2, February 1945, various pages.

25 Published in *Twice a Year*, Spring/Summer, Fall/Winter, double number XII-XIII, 1945. Caption ascribed to Dorothea Lange but actually written by her friend and assistant, Christina Gardner, 323-4. Lange's son Daniel and brother Martin were working in the Richmond Shipyards at this time. See Meltzer, 247-49, about the different working approaches of Lange and Adams.

26 Adams to Lange, 1962, CCP/UA.

27 Adams to George Marshall, 23 December 1950, in David L. Jacobs, "Three Mormon Towns," *Exposure*, vol. 25, no. 2, 6.

28 From "A Personal Credo," 1943, reprinted in Beaumont Newhall, ed., *Photography: Essays and Images, Illustrated Readings in the History of Photography* (Boston: New York Graphic Society, 1980), 257.

Figure 14 BEAUMONT NEWHALL, *Nancy Newhall, New York,* 1946.

THE IS THE AMERICAN EARTH: A COLLABORATION BY ANSEL ADAMS AND NANCY NEWHALL

◼ver a period of two decades beginning in the 1950s, Ansel Adams and Nancy Newhall undertook a number of collaborative exhibition and publication projects. While history has attached Adams' name to these projects, too often Newhall's role and her unique working relationship with Adams have not been given full attention. Because of its impact within the national environmental movement, *This Is the American Earth* can be seen as their most broadly influential collaboration, yet while it was clearly a joint effort, Newhall's involvement in its creation was much greater than has been afforded her. Adams and Newhall

initially created *This Is the American Earth* as a Sierra Club exhibition in 1955. In 1960, the Club published a reconsidered version of their show as the first volume of its highly successful "Exhibit Format" book series (figure 15), and the popular book sold some 200,000 copies in hard and soft cover before going out of print in the 1970s.[1]

Nancy Wynne Parker was born in 1908 in Swampscott, Massachusetts. As a child, she became involved in painting and writing; her first poetry was published at age eleven. In 1930 she graduated from Smith College in creative writing and painting; she then moved to New York City, where she attended the Art Students League and studied painting and engraving. In 1933, Nancy met Beaumont Newhall, and they were married three years later. She accompanied him on a trip to Europe while he conducted research for his seminal exhibition, *Photography, 1839 to 1937*, which was presented at New York City's Museum of Modern Art. Intrigued by the medium, she gave up painting to devote her time to photography.

The Newhalls met Ansel Adams in 1939 in New York. In 1940, they visited him in California, and the photographer

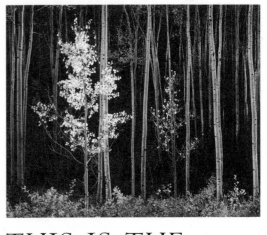

Figure 15 Cover of *This Is the American Earth.*

took them to Yosemite National Park as well as to Carmel, where they met Edward Weston. That same year, the photography department at MoMA was established, and Beaumont was named curator. When Beaumont was called into service during the war, Nancy became acting curator, and in this role she organized exhibitions on the work of Eliot Porter, Harry Callahan, Aaron Siskind and Ansel Adams. In 1945 she directed a major retrospective on the work of Paul Strand; she organized a similar retrospective on Edward Weston the following year. After the war, the MoMA board of directors decided to change the emphasis of their photography presentations, and Edward Steichen, who favored a more thematic, less academic approach, was given the curatorial position. Beaumont became director of the George Eastman House in Rochester, New York, in 1948, and Nancy continued her work with photography. In 1950 she published the book *Time in New England*, which contained photographs by Paul Strand and text by poets, politicians and others who had written about the region.

In 1951, Newhall began a series of collaborative projects with Ansel Adams. The first was a series of articles for the picture magazine *Arizona Highways*. This led to books on Death Valley and on Mission San Xavier del Bac in Tucson, both released in 1954. In 1963 she organized a large, retrospective exhibition of Adams' photographs entitled *The Eloquent Light* for the M. H. de Young Museum in San Francisco. The exhibition was accompanied by a book intended as the first volume of her biography on the artist. The projected second volume was never completed. The Adams/Newhall collaborations continued through the 1960s, and included projects such as *Fiat Lux*, which paired Adams' photographs with Newhall's text and celebrated the 1967 centennial of the state-wide system of the University of California. Newhall died in a tragic accident on a raft trip in Wyoming in 1974.

The idea for *This Is the American Earth*, which Adams called his "most worthwhile" project with Newhall,[2] originated in 1954. The Sierra Club was under pressure from the National Park Service to expand its activities at LeConte Lodge in Yosemite National Park. The small stone building on the edge of Yosemite Valley was owned by the Park Service, but responsibility for programming fell to the Sierra Club. A Club committee of which Adams was a member developed an idea for an exhibition that would educate the public on conservation issues, and Adams, who had worked as caretaker at LeConte in the early 1920s, when the building served as the headquarters for Sierra Club summer expeditions in Yosemite and the back country, offered to take it on as a personal project. On February 27, 1954, he sent a memo to the committee that described the basic subject of the exhibition as "Conservation—both in its broad aspects as a background, and specifically in relation to the National Parks and Wilderness concepts."[3]

Given the collaborative projects in which Adams and Newhall were already involved, it was only natural that she should become a participant in this new venture, which sought to create an understanding of conservation issues through a combination of photographs and text. She began preliminary work on the exhibition while visiting the Adamses in San Francisco in April, and after a few weeks she went back to Rochester to continue her research and writing. By the end of the month, however, she had begun to discover the scope of the project. Newhall took the work seriously, reading widely on conservation and related fields to extend her comprehension of the subject. The intensity of her work is revealed in a letter Beaumont wrote to Adams in May, saying that "Books on conservation [are] piled high here and there."[4]

By June 1, Adams had completed arrangements to show the exhibition at LeConte Lodge. He had also contracted with the Academy of Sciences in San Francisco's Golden Gate Park to construct the panels on which the exhibition would be displayed as well as to host a preliminary showing before the opening in Yosemite. But Newhall was still having difficulty with her writing: "The only trouble is, the damn thing wants to be a BOOK. And cutting it down to size—compressing several volumes into one line—is taking time. Pray that eloquence and illumination descend upon me!"[5] Adams responded, "I knew it would take on book character sooner or later. We do have to recognize the immediate simplified version—the exhibit."[6] This comment reveals a role Adams played often, that of a motivating figure keeping the project on course.

Later in the month, Newhall wrote to Adams that she was still having a problem condensing the initial draft of her text: "What a subject—I had no idea of its vastness, complexity and explosiveness! Wish you was here—or I there! You've spent a lifetime in this maelstrom!"[7] And a few weeks later she wrote, "I AM making progress, but it looks to me practically geologic!"[8] By this time, however, she had established a more detailed concept of the exhibition:

> This is a show in which the facts are in images—the text cannot be too detailed or nobody can read it on their feet. A few printed dates and people, a few vital statistics, must be set in a text that runs between the images and objects with mounting excitement. The show must carry the spectator along in its current and present to him material by which he shall be able to convince himself.[9]

In his response on July 31, Adams began to show some impatience with how long the process was taking, "Your concepts are magnificent! But it is not possible to get the exhibition installed in any way until it is completed."[10] Through frequent letters and telephone calls, their discussions about the exhibition continued. One of the issues Newhall raised was how they should deal with wildlife photography in the context of the exhibition. In one letter she acknowledged:

> Eliot Porter is OK, but who has done anything magical with wildlife?—Except for a few British, most wildlifers that I have seen might just have well set up their cameras in the local museum! The damn things look stuffed! There must be good men in this field. Who are they?[11]

By early August, having finished what she referred to as the "book" and saying she could cut it down for the show easily, Newhall suggested a September opening at the Academy of Sciences, with an opening in Yosemite in the spring.[12] At this point, however, she was still looking for a title for the exhibition, and in several letters she asked Adams for his suggestions. Despite Newhall's optimism about completing her work, in late September Adams found it necessary to write to her, "Academy ready to go as soon as show is ready."[13]

While there are a variety of reasons for the delays in addition to the complexity of the exhibition itself, the primary one was that Adams and Newhall were involved in other projects, together and individually. The great enthusiasm they had for their work often led to unrealistic goals for completion and they had a tendency to see projects in isolation, without considering the time demands of other activities. During late 1954, for example, both the Death Valley and the San Xavier del Bac books were in production and on press.

Another book, *A Pageant of History in Northern California*, was still in preparation. Sponsored by the American Trust Company, which has since been become a part of Wells Fargo Bank, this was to be a history of Northern California that combined Adams' pictures and Newhall's text. As *This Is the American Earth* was being organized, Adams was traveling around the state making pictures for *Pageant of History*, and Newhall was completing her text. It is clear from their correspondence that this project, which had a more immediate deadline, and for which they were receiving compensation, took a significant amount of their time.

By November, Newhall's text for the Sierra Club exhibition was apparently in near-final form, and she was seeking appropriate pictures to include. These were not always located easily, and one of her letters to Adams reflected how much simpler the *Pageant of History* project was:

> But there are still gaps where NO images have turned up. Wish THIS were such a job as the Bank Book, where we could hunt the country over for the images we need— and you could make all of them! I'm NOT wishing a terrible burden on you—it's just that I am spoiled and there are so few even PASSABLE photographers and so many fewer GOOD ones, and practically NOBODY with your skill, imagination and devotion to get the image that has such power over the mind. The little documentary images I have gathered all need a jab in the arm.[14]

Newhall went to San Francisco for several weeks in December, and during this visit she and Adams finalized the text and image selection. Since they were working one-on-one, there is no written record remaining to provide insight about their discussions. This is particularly unfortunate since it was apparently during this time that they decided the title should be *This Is the American Earth*.

In spring of 1955, Adams began making the exhibition prints. In addition to printing his own negatives, he printed those sent by other artists, among them Barbara Morgan, Eliot

Figures 16,17
Installation view of
This Is the American Earth, from original exhibition.

Porter, Margaret Bourke-White, Minor White and Edward Weston. From Rochester, Newhall wrote to Edward Weston in Carmel with a rush request for prints, suggesting that Adams could make them if he could not. He responded on March 2:

> *I can't do any rushing, so I guess the alternative would be for Ansel to print for me! Having gone thus far I might as well go the limit and agree to the proposed enlarging. In case I sound flippant about it I'll say that there are few I would delegate a printing job to from some of my favorite negatives. Believe me....Brett snorted when I told him about enlarging. I am older, thus more pliant. But he's right. Just one thing, don't rush me—you N. Yorkers.*[15]

By making the prints himself, Adams was able to control size relationships between images in accordance with the design Newhall was creating for the exhibition panels. This was not an unusual way for such exhibitions to be prepared during the 1950s, but not everyone cooperated. Brett Weston sent his prints with a note enclosed saying, "Here are the prints, forgive delay....I have no enlarger and of course never let others make prints for me. I was shocked that Dad agreed."[16]

This Is the American Earth opened at the Academy of Sciences on May 8, 1955, installed on fourteen panels, each seven feet by four feet. It comprised 102 photographs; fifty-four by Ansel Adams and forty-eight by thirty-nine other individuals and sources. Newhall's text, which took the form of a long, narrative poem, was distributed through the panels to enhance the relationship between words and pictures.

The first panel contained six photographs and set the stage as an introduction to the exhibition (figure 16). This was followed by panels that described how western civilizations tended to consume the natural resources around them as they developed, brought Europeans to the New World and talked about the impact of vast wilderness on the settlers' westward expansion. The fourth panel was denser, with eighteen smaller photographs and text that addressed the history of conservation and the development of ideas for national

parks. Following this was a panel that outlined specific problems in the West, particularly water and water usage.

The next two panels presented a non-photographic comparison of Native American and European impact on Yosemite Valley. These were followed by panels on land use, on the positive aspects of the wilderness experience and on the value of the National Parks and Monuments as places set aside to preserve wilderness. Following another painted panel with a conservation plan for Yosemite Valley, the final two panels ended the exhibition with a poetic evocation of the necessity of conservation (figure 17).

After its San Francisco showing, This Is the American Earth opened at LeConte Lodge in June and stayed in Yosemite through the summer; it was seen by thousands of park visitors. Organizing the exhibition took a year longer than Adams had originally planned—it is clear from the early Adams memos of February 1954 that he anticipated the exhibition opening that year, rather than the following summer—but the goal of bringing the conservation message to large numbers of people was grandly achieved.[17]

The enthusiastic acclaim for This Is the American Earth during the summer of 1955 spurred Adams and Newhall on to begin work on the book, but again progress was slower than they had anticipated. The different design demands of the book form and the need to address a national audience, as opposed to one experiencing an exhibition within the context of a national park, led them to reassess the nature of their message. Publishing also created a more complicated financial situation than had the exhibition. David Brower, the Sierra Club executive director, quickly saw that the book would enable the Club to bring the exhibition's uplifting conservation message to a national audience, and he actively championed the project. He also foresaw a more political use for the book, feeling that if he could place This Is the American Earth in front of members of Congress it might influence their vote on the long-awaited Wilderness Act legislation that was then under discussion.[18]

Even though the Sierra Club had been an active book publisher for a number of years, This Is the American Earth was to be a different kind of book for them, and Adams, Newhall and Brower faced some opposition to their plan. At an editorial board meeting on March 15, 1958, some members apparently raised questions about what the book would accomplish. The following day, Adams wrote to Brower confirming the position he had taken in the meeting.

> We must bear in mind that this is a poetic concept, blending the emotional effects of the images and the words into a unique single expression. While Nancy and I fully intend to make such adjustments as are aesthetically required to present this statement on a sequence of pages...any basic change of character of the project cannot be considered. We are not concerned with the production of a conventional book. The "book" is not one that is to be "read" from cover to cover. It is to be experienced on its own terms. It could be considered a "picture book" and also an extended poem. It will be actually a combination of these. The layout and "flow" will be designed to create a series of emotional impacts, and it is presumed that the reader...will not be constrained to follow the book in a cover-to-cover direction. It is NOT a collection of pictures with descriptive text. Pictures and text are a unit of expression. On this fact the project stands or falls.[19]

Adams also wrote to Newhall and reported that he had defended her against the suggestion

by some board members that her language could be less "charged." He had told the board, "you might agree to small adjustments...but...you could not be expected to violate any creative, poetic patterns which are so definitely yours."[20] He also reconfirmed his commitment to the collaboration, saying, "My pictures cannot be used separately—this is an AA and NN combination, and thus it will remain."

By mid-1959, preparations for the book were completed; both the text and the selection of photographs had undergone major revision as Newhall created the design of the book. Arrangements had been made for financial support from private donors, and *This Is the American Earth* went into production. Adams had always demanded the highest quality reproduction when his work was published, and this background led him to assume a major role as production manager. The Sierra Club was the publisher, and the book was to be offered to members by direct mail as well as distributed nationally. As it was published in December 1959, *This Is the American Earth* contained eighty-four photographs, forty-three by Ansel Adams, the rest by thirty-one others.

It is an indication of how much the book had changed from the exhibition that only thirty-five of its images were among the 102 in the exhibition. There were also many refinements in the text. The basic concept was the same—to provide a meaningful, educational message about conservation—but there was less specific reference to the National Parks and greater emphasis on the need for a more broadly based environmentalism. The text and the image selection in the book clearly represent an evolution of Newhall's and Adams' thinking, and even though the message was created more than thirty years ago, it is remarkable how viable it is today. The book opens with an introductory section of words and pictures, placed before the title page; Newhall's text reads:

> *This, as citizens, we all inherit. This is ours, to love and live upon,*
> *and use wisely down all the generations of the future.*
>
> *In all the centuries to come*
> *Always we must have water for dry land, rich earth beneath the plow,*
> *pasture for flocks and herds, fish in the seas and streams,*
> *and timber in the hills.*
> *Yet never can Man live by bread alone.*
>
> *Now, in an age whose hopes are darkened by huge fears—*
> *—an age frantic with speed, noise, complexity*
> *—an age constricted, of crowds, collisions, of cities choked*
> *by smog and traffic,*
> *—an age of greed, power, terror*
> *—an age when the closed mind, the starved eye, the empty heart,*
> *the brutal fist, threaten all life upon this planet—*
>
> *What is the price of exaltation?*
> *What is the value of solitude?*
> *—of peace, of light, of silence?*
>
> *What is the cost of freedom?* [21]

This passage, which reflects the narrative tone of the entire text, suggests a strong

influence of such poets as Robinson Jeffers and Walt Whitman. The words express the conservation ethic in a manner that aggressively engages the reader, but it is the combination of Newhall's stirring text with photographs such as Adams' *Winter Sunrise, The Sierra Nevada, From Lone Pine, California,* and Eliot Porter's *Arctic Tern, Mantinicus Rock, Maine* that makes such a powerful statement. The marriage of image and text in this introductory section establishes the dynamics of the rest of the book and demonstrates the persuasive union that can be achieved through the joining of carefully crafted text and photographic images.

The body of the book comprises six sections. The first three of these—*Brief Tenant, New World* and *The Machine and the New Ethic*—follow the flow of the earlier exhibition. The fourth section, *The Mathematics of Survival,* introduces concepts that were not included before. Newhall's angry, impassioned narrative asks, "And to what shabby hells of our own making do we rush?"[22] and her sobering answers are accompanied by photographs by William Garnett of smog and urban sprawl in Los Angeles, by Wynn Bullock of an eroded bank and by Ferenc Berko of a densely crowded riverside in India—photographs that address the negative impact of industrialization, urban development and overpopulation.

In the fifth section, *Dynamics,* not only does Newhall's text adopt a more optimistic tone in suggesting that answers to environmental problems lie in a consideration of the elemental forms of nature, but the photographs, Edward Weston's plant-covered hillside at Point Lobos or Cedric Wright's newborn fawn, for example, urge a close inspection of details. This is yet another example of how photographs and text combine to create a synergistic effect. The final section of the book, *The Crucial Resource,* suggests that the human spirit holds the ultimate answer to how the earth can be saved, and that one may nurture that spirit by experiencing wilderness intensely. The text is accompanied by a series of what are now very familiar Adams photographs, among them *Frozen Lake and Cliffs, Sierra Nevada, Sequoia National Park; Clearing Winter Storm, Yosemite National Park; and Mount McKinley and Wonder Lake, Denali National Park, Alaska.* The last photograph, *Aspens, Northern New Mexico,* is set against the words, "Tenderly now let all men return to the earth."[23]

The book was both a critical and a popular success, and it won awards from both the American Library Association and the printing industry. The entire press run of ten thousand copies was sold within twelve months. David Brower's goal of using *This Is the American Earth* to reach the general public was fully realized, and the book had a dramatic impact on the growth of the Sierra Club in the 1960s. In his 1988 history of the Club, Michael P. Cohen described the intention of the book and exhibition and assessed its impact:

> This Is the American Earth *would not only set the standards in the field, it would present the Sierra Club vision as a philosophical standard for the nation to live up to. Most important, it would attempt to present the conservationist message in positive terms, as a celebration.*[24]
>
> *The Club would become known in some circles not as an organization, but as the producer of Sierra Club Books.* [25]

Indeed, as the first of the Club's "Exhibit Format" series, *This Is the American Earth* set a standard of high-quality reproduction and large format that came to influence not only future Sierra Club books but the "look" of photography books in general over the next two

decades. The book also reflected the change of outlook that was taking place in the environmental movement in the late 1950s and 60s, one that marked an expansion of ideas about nature, conservation and the preservation of wilderness in the National Parks to a reliance on global environmentalism as the necessary means of preserving the planet.

Ansel Adams and Nancy Newhall could not have produced such a successful result as *This Is the American Earth* if they had not been able to establish a collaborative style that allowed each to contribute positively toward their goal. Many clues to this style are contained in the correspondence between them, and while the following thoughts are primarily derived from letters between 1954 and 1960, they likely hold true to their many projects undertaken over a period of twenty years.

Adams and Newhall held a clearly stated sense of mutual support and admiration for each other's skills. In his letters to both Beaumont and Nancy, Adams frequently urged that she should develop her writing in personal projects, beyond those done with him, and Adams was quick to congratulate her about her work. Once *This Is the American Earth* was installed at the Academy of Sciences, he wrote to her, "I must say, in looking at your work and reading your texts, that you have the extraordinary gift of organization, intensity, and beauty which no one else I know of possesses. I am sure you would be proud of this exhibit throughout."[26]

Newhall repeatedly praised Adams for his photography, and she often asked him to critique her ideas about conservation. It is interesting that such comments rarely appear in his letters, but he must have made them—most likely in telephone calls that allowed a more immediate give and take—since the primary environmental concepts expressed in the text are those Adams had long espoused. The trust between the collaborators was revealed in a letter Newhall wrote to Adams on May 5, 1954, with the extraordinary statement: "You are to say or do or change anything in this show exactly as you see fit. You can always sign my name to anything."[27]

In the written salutations of their letters, Adams and Newhall reveal a genuine friendship, not just a mutual passion for photography. While most were simply *Dear Nancy* or *Dear Ansel*, many were more effusive. In Adams' letters, he tended toward the mythic: *Dear Sappho; Dear Cleopatra; Dear Minerva; Dear Persephone.* Her letters to him showed a range of admirations: *Dear Prince; Dear Voice of the West; Dear Morning Star; Dear Beard; Dear Winged Whiskers; Dear Beard of the Inner Eye; Dear Beard of the Evening Beautiful Beard; Dear Emperor of Photography.*

The content of their letters was not limited to professional issues, and they shared interests such as events involving the Adams' children—Michael's marriage and military service or Anne's studies at college, for example. During this period, the Newhalls bought a house in Rochester and did some remodeling; there was a fire in the house, and Beaumont was hospitalized briefly with smoke inhalation, all of this reported in letters to Adams.

Other letters included discussions of broader social and political issues of the 1950s, such as the investigations by Senator Joseph McCarthy into photographers, Adams and Beaumont among them, who had been members of the Photo League. The threat of nuclear war had its impact on Adams and the Newhalls as well. This is clear in several passages in Newhall's text of *This Is the American Earth*, and Adams' personal concern is evident in a letter he wrote to Newhall on April 30, 1954, that expresses a feeling of futility about his work.

The world is in a state of horror or sublimity. Frankly, the Fireball can do away with thee and me at any moment. All that we have done, all that ages have accomplished may melt in a millionth of a second.[28]

It was Beaumont, rather than Nancy, who responded a few days later with encouraging words that suggest he understood the importance *This Is the American Earth* would have.

There cannot be a man of any sensitivity today who is not shocked, bothered and distressed by every issue of the newspaper....In the face of all the present turmoil and unrest and unhappiness....what can a photographer, a writer, a curator do?....To make people aware of the eternal things, to show the relationship of man to nature, to make clear the importance of our heritage, is a task that no one should consider insignificant...These are days when eloquent statements are needed.[29]

Ansel Adams and Nancy Newhall, as friends and collaborators, were remarkably successful in creating the kind of "eloquent statement" that had the power of beauty and persuasion. The key to this lies in the constant communication between them in phone calls and letters. One of the qualities that such frequent communication engendered was an openness to giving and receiving critical suggestions. For example, after publication of the book, Adams wrote to Newhall, Brower and the book's printer with his comments. His memo began, "In my opinion this book is an outstanding job in every respect, and my critical comments are given with a constructive spirit; more as observations than criticisms, except for a few points." He then presented two single-spaced pages of comments, most of them about images that could have had better reproduction. In a congratulatory final comment about the success of *This Is the American Earth*, he concluded, "All in all—it is a MAGNIFICENT production!"[30]

NOTES

[1] As a part of its 100th anniversary celebration, the Sierra Club reissued *This Is the American Earth* in 1992. An exhibition drawn from the book and organized by this author opened at the Ansel Adams Center in San Francisco in September 1992. From there it will travel to the American Museum of Natural History in New York City and tour four cities in Japan before opening at the Yosemite Museum in Yosemite National Park in late May 1993 for a summer-long venue.

[2] Ansel Adams with Mary Street Alinder, *Ansel Adams: An Autobiography* (Boston: Little, Brown and Company, 1985), 215.

[3] Adams, memo to Sierra Club, 27 February 1954, The Ansel Adams Publishing Rights Trust (hereafter cited as AAPRT).

[4] Beaumont Newhall to Adams, 24 May 1954, Ansel Adams Archive, Center for Creative Photography, University of Arizona (hereafter cited as CCP/UA).

[5] Nancy Newhall to Adams, 1 June 1954, Adams Archive, CCP/UA.

[6] Adams to Nancy Newhall, 5 June 1954, Adams Archive, CCP/UA.

[7] Nancy Newhall to Adams, 10 June 1954, Adams Archive, CCP/UA.

[8] Nancy Newhall to Adams, 28 June 1954, AAPRT.

[9] Nancy Newhall to Adams, 21 June 1954, Adams Archive, CCP/UA.

[10] Adams to Nancy Newhall, 31 July 1954, Adams Archive, CCP/UA.

[11] Nancy Newhall to Adams, 21 June 1954, Adams Archive, CCP/UA.

[12] Nancy Newhall to Adams, 2 August 1954, Adams Archive, CCP/UA.

[13] Adams to Nancy Newhall, 26 September 1954, Adams Archive, CCP/UA.

[14] Nancy Newhall to Adams, 27 November 1954, Adams Archive, CCP/UA.

[15] Edward Weston to Nancy Newhall, 2 March 1955, AAPRT.

[16] Brett Weston to Nancy Newhall, postcard, 5 March 1955, AAPRT.

[17] After Yosemite, the exhibition went to the Stanford University Library, and then to Boston's Science

Museum. Following these venues, it was circulated by the Smithsonian Institution within the United States until 1959, and four duplicates were toured overseas by the United States Information Agency.

[18] David Brower to Nancy Newhall, 7 February 1958, AAPRT.

[19] Adams to Brower, 15 March 1958, AAPRT.

[20] Adams to Nancy Newhall, 27 March 1958, AAPRT.

[21] Ansel Adams and Nancy Newhall, This Is the American Earth (San Francisco: Sierra Club Books, 1992), iii-viii. The Newhall text in this new edition is unchanged from the 1960 edition. The book does, however, have some minor changes in design and picture selection. Like the first edition, the reproduction quality is "state-of-the-art" for its time.

[22] Adams and Newhall, 45.

[23] Adams and Newhall, 88.

[24] Michael P. Cohen, The History of the Sierra Club, 1892-1970 (San Francisco: Sierra Club Books, 1988), 256.

[25] Cohen, 259.

[26] Adams to Nancy Newhall, 9 May 1955, AAPRT.

[27] Nancy Newhall to Adams, 5 May 1955, Adams Archive, CCP/UA.

[28] Adams to Nancy Newhall, 30 April 1955, Adams Archive, CCP/UA.

[29] Beaumont Newhall to Adams, 3 May 1955, Adams Archive, CCP/UA.

[30] Adams, memo to Nancy Newhall, David Brower, Peter Convente, 10 January 1960, AAPRT.

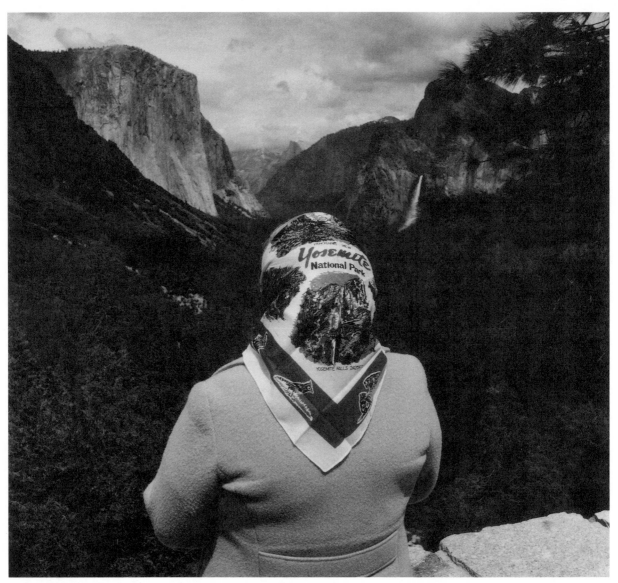

Figure 18 ROGER MINICK, *Yosemite National Park*, 1980 (original in color).

Renée Haip

ANSEL ADAMS:
FORGING THE WILDERNESS IDEA

According to Ansel Adams, he "never intentionally made a creative photograph that related directly to an environmental issue."[1] Yet, at the end of his life he was equally noted for his creative photography and his environmental activism. His words and images stirred the general public as well as the leaders of the country. His photographs, which have been called "trophies from Eden,"[2] beckon people to see, experience and preserve the beauty in nature. In Ansel Adams' world, we do not expect to encounter other people or traffic jams; nor do we expect to find cigarette butts among the rocks or hear snapping shutters or motor winders. People assume that the Yosemite Adams photographed was undefiled nature; they fail to realize that power lines, crowds and litter were part of the Yosemite Valley of the 1920s and 30s. Adams chose to edit out these undesired elements. His photographs depict the national parks as Americans believe them to be—as "wilderness areas." Adams' images present an ideal; they build expectations within us. Our concept of what wilderness is and how it looks has, in part, been shaped by Ansel Adams.

When Adams was photographing the national parks in the 1920s and 30s, frontier ethics were still solidly in place. The parks were viewed and managed more as pleasuring grounds than as protected natural areas. Yosemite National Park, for instance, possessed such amenities as a bowling alley and ice-skating rink. People touring the West returned home with grand stories of rangers feeding bears at Yellowstone, of drives through the Shrine Tree in the Redwood Forest, and of the firefall in Yosemite, where bonfires were pushed over the edge of Glacier Point to cascade 3,000 feet to the valley below. The commercial exploitation of our first national parks was acceptable to the general public.

Beginning in 1929, Adams himself took on commercial assignments for the Yosemite Park and Curry Company, which runs public concessions in Yosemite. At times they used his creative work, but more often they used contracted images which depicted Yosemite

Figure 19 Cover of *The Argonaut Magazine*, cover image by Adams.

National Park as a playground (figure 19). Images of people relaxing and playing in Yosemite were used in advertisements and magazine articles with the goal of boosting tourism and thus turning a bigger profit for the concessionaires.

Ansel Adams and the Sierra Club

It was through the Sierra Club that Adams and his photographs made their initial contributions to environmental causes. Through his association with the Sierra Club, which began in 1919 and lasted throughout his life, Adams was introduced to the concepts of wilderness and to like-minded friends.

It is important to put the Sierra Club of yesteryear into context— by today's standards, even they participated in exploitive ventures. When Adams joined, the Club's official mission statement began with "To explore, enjoy, and render accessible the mountain regions of the Pacific Coast."[3] As frontier ethics dominated the west, wilderness lovers looked east for support in preserving wild lands. It was felt that wilderness must be made accessible for urban supporters to visit. For this reason, development of wild lands, which included road building, was promoted by the Sierra Club as a means to preserve them in the form of national parks. [4]

During the first decade and a half of Adams' involvement, the Club was active in exploring and mapping the Sierra Nevada, and concentrated on making the mountains accessible through the building of trails. In the early 30s, Adams assumed leadership as Assistant Manager of the Sierra Club Outings. The annual month long outing, coined the "High Trip," was intended to provide fellowship and build appreciation of the natural landscape by exposing people to wilderness. It was hoped that upon returning home, the participants would work to protect these areas through legislation. Unfortunately, the "High Trip" was not without negative impacts, as it generally involved about 200 participants, 50 helpers, and pack animals (figure 20). Adams listed as common practices pine bough cutting for bedding material, firewood cutting, burying trash and throwing cans down rock crevices to be covered by a rock.[5]

In 1934, at the age of 32, Adams was elected to the Sierra Club Board of Directors. In his position as a Board Director, Adams had the opportunity to play an important role in guiding Club policy for 37 consecutive years. Michael Cohen's history of the Sierra Club identifies Ansel Adams, David Brower, Richard Leonard and Bestor Robinson as characterizing the third generation of Club leaders. Cohen wrote that they "represented the new aesthetic, philosophic, analytic, and practical directions for Club thinking."[6] Under their leadership, the Sierra Club formulated new ideas as its past policies and attitudes relating to recreation and national parks were reconsidered. By the late 1940s, it began to question the ecological consequences of the outings, and by the 1960s the traditional high trips were discontinued.[7]

In keeping with the values found in Adams' images, an environmental ethic and philosophic vision was developing which supported the idea of "true" wilderness reserves. In 1951, emphasis was taken away from "making accessible" and given to preservation of

wild lands, as the Club revised its statement of purpose to read "To explore, enjoy, and preserve the Sierra Nevada and other scenic resources of the United States."[8] As well, the Club concentrated on the battle to pass and implement a national wilderness bill.

Adams' biggest impact through the Sierra Club must be identified as the effective use of his images, which became intimately associated with the Club's own image through reproduction in the Sierra Club Bulletin and other publications. One of the most widely cited examples of Adams' photographs impacting an environmental issue is his involvement in the 1930s campaign for Kings Canyon National Park. Adams' personal contributions through his lobbying efforts and the publication of *Sierra Nevada: The John Muir Trail* (1938) proved to be a great asset to the campaign. After the national park was established in 1940, Arno Cammerer, Director of the National Park Service, wrote to Adams: "I realize that a silent but most effective weapon in the campaign was your own book...So long as that book is in existence, it will go to justifying the park."[9] The success of this book as an unintentional yet persuasive political tool made it clear to Adams and the Sierra Club that publishing quality photographs could help them meet their objectives. In having the ability to move people on both an emotional and aesthetic level, his photographs created a powerful base from which he could work.

Building on Adams' suggestions and comments concerning the dull format of conservation literature, the Sierra Club set out to appeal to a broader audience through new publishing ventures.[10] The Club launched its Exhibit Format book series in 1960 with the publication of *This is the American Earth*. This book was given to members of Congress and the Senate, and won critical acclaim for the Club.[11] Distributed nationally, Exhibit Format books found their way to the coffee tables of thousands of American homes. The books

Figure 20 ANSEL ADAMS, *Sierra Club High Trip.*

pushed to revise the myths about wilderness and to change public attitudes about wilderness and conservation in general.

Adams' impact as an individual

Adams' impact on the environmental movement went beyond the effective use of his photographs and his role as Director of the Sierra Club. His immense concern over a proposed road at Yosemite's Lake Tenaya in the late 50s drove him to break from traditional Sierra Club channels by resigning and personally exercising his own influence with Washington officials.[12] Although the road at issue was built according to plan, the situation had strengthened his positions against further development in the national parks. In the closing lines of a July 1957 letter to upper level Sierra Club officials, Adams wrote:

> *I think we must take the attitude that—in the face of the enormous spiritual and inspirational value of the Parks and the wilderness areas—NO bureau, no plan, no established project, no road, no concessionaire, no works of man of any kind has consequential value. We must proceed as if all of these factors did not exist. They are expendable—the Parks are not.*[13]

By the 1960s, Adams had become an influential figure generally respected by politicians, the art community and the American public. His opinions were solicited, as he was beginning to take on the status of a folk hero. The Sierra Club's stature had also been transformed. No longer a local, elitist organization, the Club had become a popular national organization with a multi-million dollar budget and an expanded scope that included lawsuits and directed activism against such environmental threats as nuclear power. Adams felt he did not have the technical expertise to be effective in light of the "new" Sierra Club. Furthermore, Adams was disillusioned with what he termed the "shin-kicking" tactics of the 1960s under executive director David Brower as communications broke down between the Club and federal agencies, notably the United States Forest Service.[14]

In July of 1959, Adams wrote his friends, Wilderness Society President Olaus Murie and his wife Margaret, expressing his resolution to speak out in defense of the environment on every possible occasion.[15] This resolution was demonstrated by an extensive letter writing campaign to governors, presidents, senators, congressmen and other public officials.

In the 1970s, increasing pressures mounted as demands for Adams' time grew. In addition to the time he spent on his art, Adams continued to devote himself to environmental concerns, speaking at conferences, granting interviews, sitting on advisory boards, providing photographs and lending the prestige of his name to various fundraising efforts. Adams clearly had become an authority—not as a result of formal education but through his life's passion of focusing his artistic endeavors and political activism on the natural landscapes he loved.

Advancing age necessitated that Adams make scheduling decisions based upon maximum effectiveness. In 1971, he made two decisions that helped him realize this goal. He resigned from the Sierra Club Board of Directors, a decision that gave him greater freedom to speak as an individual, as he felt that he could accomplish as much or more as a regular member of the Club.[16] As well, Adams hired William Turnage as his full-time business manager and to provide advice on setting priorities.

Time pressures did not allow Adams to accept invitations to participate in every

conference he considered important. However, at times, Adams suggested that Turnage be his representative. In 1972, Turnage represented Adams at the Conservation Foundation's Symposium on the National Parks and the Second World Conference on National Parks. His confidence in Turnage's ability to represent him gave Adams a "voice" despite the lack of his physical presence. With Turnage's 1978 appointment as director of the Wilderness Society, Adams aligned himself closely with this organization, and generously contributed to its causes (figure 21).

The wilderness image—vehicle for renewal or exploitation?

In the latter part of Adams' career, his images and endorsements were not only sought by environmental organizations such as the Wilderness Society, but also by advertising agencies and by companies desiring non-contextual illustrations. His name and his images lent clout, prestige and selling power. In 1969, Hills Brothers printed one of Adams' Yosemite photographs on their three-pound coffee can (figure 22). In 1973, Adams cooperated with Nissan Motor Corporation's campaign "Drive a Datsun, Plant a Tree." In the television ad, Adams is shown working with his camera next to a Datsun vehicle on a forest road. In the commercial he states:

> A forest **can** rebuild itself, but the same type of trees may not grow back. And it takes a long time...sometimes as long as eighty years. When man gets involved, nature needs a helping hand....Companies like Datsun, the car company, are paying for thousands of seedlings to be planted in National Forests throughout our country. Through programs like this, we can help nature rebuild[17]

Figure 21 Wilderness society brochure.

Figure 22 Hills Bros. coffee can.

While Adams had made his living as a commercial photographer, his fame and influence were tied to creative photography and environmental protection. According to his autobiography, Adams evaluated his responsibilities and ethics:

> *Since my participation in the Datsun advertisement over ten years ago, I have not allowed the association of my photographs with a commercial product. I have been offered extravagant sums of money with the intention that* Winter Sunrise *be splashed across magazine pages and billboards on behalf of a whiskey. I choose instead to have images reproduced on behalf of the causes I believe in: creative photography and environmental protection.*[18]

However, according to Turnage, Adams had actually responded to criticism about the Datsun commercial by proclaiming that he was not a "tin Jesus." He continued to allow his photographs to be used in association with commercial products as is evidenced by the use of his photographs in a Wolverine sporting goods advertising campaign.

Adams' influence and selling power has not waned since his death in 1984. His images are still found supporting the causes he believed in. In recent years, The Wilderness Society's solicitation for memberships centered around the promise of a free gift, *Celebrating the American Earth*, a "spectacular softbound collection of Ansel Adams' photographs."

In 1986, Rockwell International utilized Adams' photographs in a series of three ads pairing Yosemite National Park with Tactical Weapons Systems, the Sierra Nevada with the U.S. Air Force B-1B long-range combat aircraft and the California Redwoods with the space shuttle. These ads ran in four defense and aerospace publications, as well as *The National Journal*, a political weekly. The public, having long ago put Adams on a "purist" pedestal, cried out with such great disapproval that Rockwell quickly abandoned the ad campaign.

These ads generated much debate about whether or not Adams would have allowed the use of his photographs in this context. In actuality, Rockwell International had been granted permission to use the photographs in conjunction with their corporate image by The Ansel Adams Publishing Rights Trust.[19] Without the Trust's permission, Rockwell tied Adams' images to specific products including a nuclear weapons system. Even though Adams had expressed great concern about the proliferation of nuclear weapons and the dangers of a nuclear war,[20] his photograph *Clearing Winter Storm, Yosemite National Park* suddenly was found in a two-page spread touting the phrase "Like Yosemite National Park, Tactical Weapons Systems are a national resource."[21]

Ansel Adams' words and images, as well as the "wilderness idea" have become a commodity. Ad executives continue to draw upon the wilderness image to sell a variety of consumer products from clothing to automobiles. Like the publishing programs of the Sierra Club, contemporary magazines such as *Outdoor* and *Backpacker* call attention to the splendor of our country's wild lands. These magazines spoon-feed the "masses" with information about where to go, how to get there and what to take. They funnel people into specific areas, some of which are fragile and unable to handle large numbers of people. *Backpacker* writer and field editor Jeff Rennicke justifies this practice by citing the loss of Glen Canyon to dam builders. He goes on to tell of the successful fight to keep a similar dam out of Dinosaur National Monument.[22] However, he fails to talk about the context in which the work is published. Publishing a travel-type article in a major commercial magazine has

an entirely different impact than publishing a campaign article in a nonprofit environmental publication.

It is true that through publishing, one may bring about popular support and "added" protection for an area. In all probability, however, the exposure will also create an entirely new set of problems including overuse by the area's well-intentioned admirers. Many photographers, who may believe that they are working in the tradition of Ansel Adams, publish their images without studying the particular positive and negative ramifications that publishing may have. Photographers who work from a position of fad and salability pose a great danger to wilderness areas, designated or not. As a rule, Adams approached the landscapes of Northern California from a position of knowledge and understanding. He understood the politics of the region; he knew the politicians, the park managers and the park defenders.

While his work outside his home territory built support and credibility for other regions such as the Alaskan wilderness, it also illustrates the potential dangers of working in areas not fully understood by the photographer. This is best illustrated by his 1947 critical remarks about Organ Pipe and Saguaro National Monuments. Of Organ Pipe he wrote: "Considerably over-rated to my mind. Not sufficiently developed to take advantage of possible high spots. As a National Park it is ridiculous. But there is lots of pressure to make it one."[23] Of Saguaro National Monument he wrote: "Should be given back to the Indians. I got my best Saguaro pictures in Organ Pipe, N.M."[24] Uncharacteristically, in these cases Adams seemed to be reacting from a pictorial perspective with little regard for these unique ecological systems.

One must ask if it is possible for Adams' photographs to continue exerting substantial positive impact on wilderness appreciation and protection. It is true that they continue to support the intangible values of wilderness, which are otherwise difficult to argue in a society that bases much of its decisions on quantitative information. They continue to present a standard much in keeping with the Wilderness Act of 1964, which defines wilderness as "an area where the earth and its community of life are untrammeled by man, where man himself is a visitor who does not remain."[25] His images certainly support low-impact camping, clean air standards, and when necessary, limitations protecting the landscape from people. They also affirm Wallace Stegner's acknowledgment of the spiritually redeeming qualities of nature:

> We simply need that wild country available to us, even if we never do more than drive to its edge and look in. For it can be a means of reassuring ourselves of our sanity as creatures, a part of the geography of hope.[26]

Certainly there are urgent new issues to be addressed by contemporary photographers. While Adams' photographs continue to inform viewers about the physical beauty of the land, the general public must be encouraged to look past issues of facade. Adams' photographs do not support "let burn" policies. Nor do they specifically address the wildlife issues, boundary issues or the subtleties of biotic pollution. It is now acknowledged that it is impossible to protect natural areas with the mere delineation of political boundaries. The stewards of public land can no longer manage natural areas without taking into consideration the entire ecosystem. They must consider the impacts of power plants and dams

hundreds of miles away. As well, public or government protection of wilderness lands cannot be taken for granted. In the last years of his life, Adams found it necessary to fight the Reagan administration, notably Secretary of the Interior James Watt, whose policies threatened to undermine many of the environmental advances he had supported and worked for during his lifetime.

In his closing remarks for a 1967 commencement address at Occidental College, Adams remarked:

> *If we succeed in establishing...some moratorium with destiny, if we can truly interpret what we have, as well as what we might lose forever, if we can augment the power of art as a vital factor of our lives, we may prevail in establishing protection for our remaining natural and cultural beauty, and also provide for the repair of damaged lands, environments and people! With this creative protection, conservation takes on an additional dimension.[27]*

Adams' legacy is perhaps most vital in its example of how to effectively merge art and activism. Adams was positive in his attitudes. He felt strongly that the response of "NO" should be followed by an alternative. And he believed that art should not only have a positive impact on people's attitudes, but should also play a role in moving people to action.

My appreciation to Dianne Nilsen, Amy Rule and Marcia Tiede of the Center for Creative Photography for their assistance in this project. Special thanks to Helen Saidel, David Such and William Turnage for their thoughtful review of various drafts. I am also grateful to Dr. Ervin Zube, Dr. James Sell and Professor Frank Gregg of the University of Arizona for their support and guidance during the research and writing of my thesis from which this essay is derived.

NOTES

[1] Ansel Adams with Mary Street Alinder, *Ansel Adams: An Autobiography* (Boston: Little, Brown and Company, 1985), 1.

[2] Hilton Kramer, "Ansel Adams: Trophies from Eden," *New York Times*, 12 May 1974, sec 2:23.

[3] Sierra Club, *Articles of Association, By-Laws, and List of Members* (San Francisco: Sierra Club, 1892).

[4] Michael P. Cohen, *The History of the Sierra Club: 1892-1970* (San Francisco: Sierra Club Books, 1988), 8.

[5] "Conversations with Ansel Adams," interview conducted by Ruth Teiser and Catherine Hamonn, with introductions by James L. Enyeart and Richard M. Leonard, (Berkeley: Regional Oral History Office, Bancroft Library, University of California, 1978), 591-593. Transcript in the Ansel Adams Archive, Center for Creative Photography, University of Arizona (hereafter cited as CCP/UA).

[6] Cohen, 67.

[7] Ann Gilliam, ed., *Voices for the Earth: A Treasury of the Sierra Club Bulletin* (San Francisco: Sierra Club Books, 1979), 136.

[8] Cohen, 100.

[9] Nancy Newhall, *Ansel Adams: The Eloquent Light* (New York: Aperture, 1963), 165.

[10] Cohen, 254.

[11] "Conversations with Ansel Adams," 462-71, 667.

[12] Adams with Alinder, 154-6; Cohen, 99-100.

[13] Mary Street Alinder and Andrea Gray Stillman, eds., foreword by Wallace Stegner, *Ansel Adams: Letters and Images 1916-1984* (Boston: Little, Brown and Company, 1988), 248.

[14] "Conversations with Ansel Adams," 596.

[15] Alinder and Stillman, eds., 259-60.

[16] Alinder and Stillman, eds., 312.

[17] Adams with Alinder, 178.

[18] Adams with Alinder, 361.

[19] In 1976 Ansel Adams established The Ansel Adams Publishing Rights Trust to oversee his work beyond his own lifetime. He appointed three Trustees and assigned to them a dual task: to protect and share his legacy.

[20] Alinder and Stillman, eds., 361.

[21] Rockwell International, advertisement for tactical weapons systems, *National Journal*, 30 August 1986, 2067-2068.

[22] Jeff Rennicke, "Giving the Land a Voice," *Backpacker,* June 1992, 65-6.

[23] Alinder and Stillman, eds., 181.

[24] Alinder and Stillman, eds., 181.

[25] The Wilderness Act: Public Law, 88-577, Eighty-eighth Congress, 1964.

[26] Wallace Stegner, "The Meaning of Wilderness in American Civilization," in Roderick Nash ed., *The American Environment: Readings in the History of Conservation* (Reading, Mass.: Addison-Wesley, 1968), 197.

[27] Ansel Adams, "Give Nature Time," commencement address to Occidental College, 11 June 1967, Ansel Adams Archive, CCP/UA, 11.

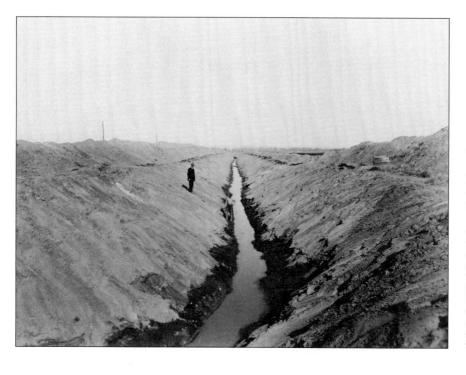

Figure 23 PHOTOGRAPHER UNIDENTIFIED, *Work being done on the Truckee Canal, part of the Truckee-Carson Irrigation Project, later named the Newlands Irrigation Project,* ca. 1905. Courtesy of the Special Collections Department, University of Nevada, Reno Library.

This Truckee Canal project was the federal government's first attempt to irrigate desert lands by diverting water from a river's source. The conflict over the Truckee continues today, as the Paiute Indians of Pyramid Lake Reservation struggle against the city of Reno, Nev., and the surrounding agricultural and ranching communities for limited water resources.

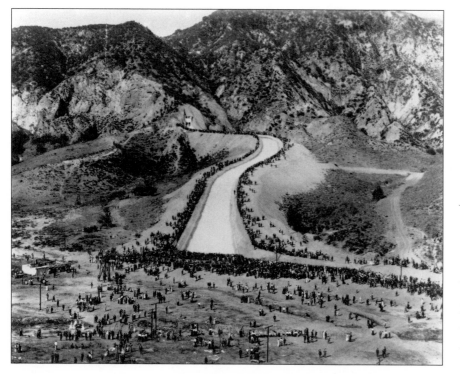

Figure 24 PHOTOGRAPHER UNIDENTIFIED, *Opening Day Ceremony, the first Los Angeles Aqueduct, San Fernando Valley, California,* November 5, 1913. Courtesy of Los Angeles Department of Water and Power.

As the first water rushed through the spillway of the aqueduct, William Mulholland, the engineer and superintendent responsible for bringing Owens Valley water to Los Angeles, addressed the crowd gathered at the elaborate festivities with "There it is! Take it!" The aqueduct set off an immediate explosion in land annexation and population in the Los Angeles area—all at a devastating emotional and financial cost to the residents of Owens Valley. In stark contrast to the previous image of Truckee Canal, this photograph documents the huge public interest in the "achievements" of modern water management in the early 20th-century.

The Water in the West Project is a consortium of photographers who are documenting water issues in the American West. To its members, water is the most compelling metaphor and prescient symbol for the legacy of attitudes that have so profoundly shaped the landscape of the West. The full range of our nation's regard for the natural world has manifest itself in Western water history—from loving stewardship and respect to outrageous abuse and plunder. Although the current water crisis is global, the Project has chosen to focus on the American West, for it is there that the impact of human settlement and resource development is immediately visible, and the potential for self-regulation and restoration is the greatest. Participants in the Water in the West Project recognize that water has played a critical role in shaping all aspects of the landscape of the American West.

The political context that Ansel Adams placed around his work is similar to the political and social interests of many of the Project's members. Adams' passion for the natural world and his outspoken activism in defense of wilderness serves as a strong model. Like Adams, these photographers are driven by the feeling that something is very wrong with our attitudes about the environment, and that photography can provide an effective way to express those concerns. Today's world is very different from the one that Adams inhabited, however, and fresh strategies are needed. Much of Adams' photography was about an ideal of nature and an abstraction called "nature." The Project is exploring several versions of nature, landscape and ecology, especially as it has been altered or shaped by human design.

The popularity of photography, both historically and today, makes it a natural medium to explore landscape issues and environmental concerns. In addition to Adams, there are many precedents for photography being employed as a tool for educating and shaping public awareness of unique American landscapes. For instance, Carleton Watkins' and William Henry Jackson's photographs of Yosemite and Yellowstone were influential in the effort to set these areas aside as parks. However, it was Ansel Adams' efforts on behalf of wilderness and parks that served as the most direct model for Robert Dawson, who had known Adams and respected his photography and his strong political views, when he began

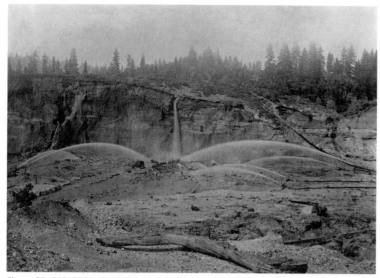

Figure 25 CARLETON WATKINS, *Malakoff Diggins, North Bloomfield, Nevada County, Cal.,* ca. 1871. Courtesy of Fraenkel Gallery, San Francisco.

Watkins, who is best known for his spectacular views of Yosemite and the California coast, was often commissioned to document mining activities in the Sierra Nevada and Virginia City regions of California and Nevada. The high pressure needed for hydraulic mining was created by impounding water in upstream reservoirs which were fed by a complex system of ditches and flumes. Angry farmers and ranchers downstream found their ponds and irrigation ditches clogged and poisoned with silt and debris from this and other mines. Watkins' photographs were used in the first environmental court case brought by the downstream farmers against the mining company. The farmers eventually won the case and, as a result, brought an end to large-scale hydraulic mining in the Sierra.

his own series "The Water in the West Project" in 1983. Dawson's extensive work at Mono Lake taught him much about the complex relationship between water, landscape, politics and art, and he soon felt constrained by the form and substance of Adams' Modernist work. Other models contributed to the Project's formation, including the Farm Security Administration's Photographic Division in the 1930s and Mark Klett and Ellen Manchester's work on the Rephotographic Survey Project in the 1970s.

Dawson and curator/historian Ellen Manchester began to talk with other photographers who shared a similar concern for landscape issues and, in 1989, invited seven artists to join the Water in the West Project. The Project has grown to include thirteen members whose work has been influenced by a variety of individuals including geographer J. B. Jackson, writers Barry Lopez and John McPhee, western historian and novelist Wallace Stegner, sustainable agriculture advocates such as Wes Jackson and Wendell Berry, environmental leader David Brower, and scholars such as Donald Worster and Marc Reisner.

Unlike the heroic model of Modernism that shaped Adams' ideas of art making, the Water in the West Project has been influenced by the Postmodern concepts of the late 20th-century. By collaborating as a group, these photographers de-emphasize the importance of the individual artist and hope that their collective energies will create products that will be greater, and more meaningful, than the individual efforts. Furthermore, in contrast to the Modernists, they place importance on the process as well as on the final product. As Project member Mark Klett states,

> I am interested in the project as an experiment in collaboration—a collaboration among photographers who are committed to Western water issues. There may in fact be diverse forms and levels of collaboration which occur between individuals and the group at large. But in general, what I am advocating is a willingness by the participants to place the goals of the group above individual gain. I think this is an extraordinary prospect. And it is different, I think, from our normal routine as photographers where we tend to function self-sufficiently, and at times, even compete with each other.

Central to the Project is the development of a state-of-the art photographic archive. The archive, and the Project itself, will serve as a clearinghouse for ideas and as a structure to encourage collaborative and interdisciplinary work on critical cultural and environmental

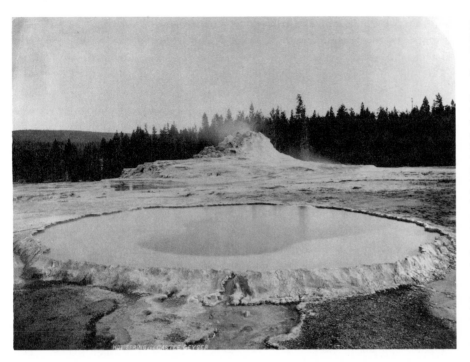

Figure 26 WILLIAM HENRY JACKSON, *Hot Springs and the Castle Geyser, Yellowstone Territory,* 1872. Courtesy of the Yellowstone National Park Collection, Wyoming.

Jackson worked closely with landscape painter Thomas Moran to document the exotic natural wonders of this region for the government's Hayden Survey. The photographs and paintings, which were widely seen by East Coast policy makers, contributed to further appropriations for survey work and to the establishment of Yellowstone as the first national park. During the "Great Surveys" of the American West, nature and landscape were often seen as a resource to be developed, controlled, and exploited, or, if too exotic to be useful, to be set aside and promoted for tourism. Adams respected Jackson and acknowledged the importance of his work in Yellowstone as a precedent to his own efforts to establish Kings Canyon National Park.

Figure 27 MARK KLETT AND GORDON BUSHAW for the Rephotographic Survey Project, *Crested Hot Springs and the Castle Geyser, Yellowstone National Park, Wyoming,* 1978. Courtesy of the Rephotographic Survey Project.

An elaborate system of boardwalks and fences protects tourists from the perils of the natural world and simultaneously shields nature from the impact of thousands of visitors each day. The Rephotographic Survey located more than two hundred sites of 19th-century landscape photographs in the American West, and made contemporary views from the exact camera location, noting geological, vegetational and cultural changes over more than a hundred years. Unlike Adams' grand and romantic vision of America's national parks, the Rephotographic Survey Project described a more realistic, and inhabited, view of the contemporary western landscape.

issues. The goal of the archive is to collect photographs that will be useful to a broad range of disciplines—from grassroots political groups to cultural geographers, historians, and the public and private sectors—in efforts to educate the public in making more informed decisions about the use of this vital natural resource. The archive emphasizes 8 by 10 inch research prints rather than precious, exhibition quality prints, and collects historical images from a broad range of sources including public and private collections, government agencies, commercial studios, Indian reservations and local and regional historical societies. These images provide an important context for the contemporary work and are useful in re-evaluating the history of our culture's attitudes toward landscape and natural resources. The archive will serve as a laboratory for work in progress and as a vehicle for bringing discussions of national and regional issues to local communities by placing the work before the public through small regional exhibitions, public forums and occasional publications. The Project is currently exploring the new CD-Rom technology as a way of further disseminating information and images from the Project.

Project photographers realize that addressing water issues in the American West goes beyond merely documenting examples of water use and abuse to include considerations of the relationship of history and culture to nature, landscape, and the environment. They are interested in combining these broader issues of cultural history with specific environmental, political and aesthetic concerns. Although the Project does not promote a specific political or environmental agenda, the group encourages members to seek affiliations and work with local and regional grassroots organizations in order to increase the effectiveness of their work.

As William Cronon writes, "…however we may feel about the urban world which is the most visible symbol of our human power—whether we celebrate the city or revile it, whether we wish to 'control' nature or 'preserve' it—we unconsciously affirm our belief that we ourselves are unnatural. Nature is the place where we are not."[1] Once nature is only seen as something that exists in parks or preserves, the rest of landscape becomes fair game to rape, pillage and plunder. The Water in the West Project focuses on our culture's relationship to, and alteration of, the landscape rather than on the redemptive qualities of wilderness as seen in Adams' work.

The Water in the West Project members include: Joseph Bartscherer, Laurie Brown, Gregory Conniff, Robert Dawson, Terry Evans, Peter Goin, Wanda Hammerbeck, Sant Khalsa, Mark Klett, Sharon Stewart and Martin Stupich. Administrative support is given by Ellen Manchester and Jane Stenehjem. The Project is sponsored by Headlands Center for the Arts in the Golden Gate National Recreation Area in Sausalito, California.

NOTES
[1] William Cronon, *Nature's Metropolis: Chicago and the Great West* (New York: W.W. Norton & Co. Press, 1991), 18.

Editor's note: *In the following portfolio, participants of the Water in the West Project reflect on Ansel Adams' legacy in terms of their own work and philosophy. The portfolio begins with Ellen Manchester's thoughts about Adams' early recognition of the politically persuasive power of photography.*

ANSEL ADAMS, *Lake Near Muir Pass, Kings Canyon National Park,* ca. 1933.

In 1924-25 and again in the 1930s, Adams traveled and photographed extensively in the Kings River and southern Sierra region of California. His images were made out of a passion and curiosity for the spectacular natural beauty of the place. In 1934 Adams was elected to the Sierra Club Board of Directors at a time when the Club's efforts to establish Kings Canyon National Park intensified. His photographs of the region were often published in the Sierra Club Bulletin, and in 1936 he was asked to lobby on behalf of the proposed park at a conference in Washington, D. C. In 1938 his photographs of the area were published in a limited edition book, *The Sierra Nevada and the John Muir Trail.* Adams sent a copy of the book to Secretary of the Interior Harold Ickes, who expressed great interest in the book and forwarded it to President Franklin D. Roosevelt. In 1940 Roosevelt and Ickes successfully pressured Congress into establishing Kings Canyon National Park. Adams acknowledges the historical precedent of the photograph as a lobbying tool by crediting Carleton Watkins' images of Yosemite and William Henry Jackson's photographs of Yellowstone as decisive factors in the establishment of the former as a state park in 1864 and the latter as the first national park in 1872. What is interesting about Adams' work in this case is that the photographs were initially made out of a personal, intuitive response to the beauty of the landscape, and were later put to use in a political context as tools for an environmental campaign. —Ellen Manchester

GREGORY CONNIFF, *Sand Hills, Nebraska; Cattle Water (Aerial 1),* 1990.

Beauty is useful and it resides in the world, not in the eye of the beholder. Ansel Adams used it in photographs that helped to direct protective attention to the part of the world that is wilderness. My regret over his work is my belief that in drawing our eyes toward sublime wilderness and away from the places of our daily lives, his photographs make an argument that beauty is *elsewhere.*

A problem with identifying beauty so strongly with wilderness is that it can divert our affection and sense of responsibility away from our inhabited local places. With some tension we come to regard the places where we live as ruined by human presence—and yet also as home. Many photographers have mined this tension; but whether documentary or reflexive-academic in nature, little serious work that I am aware of considers beauty as other than something to avoid or to patronize with irony. And with the world deep in crises there is an easy logic to dismissing as fatuous or as products of denial photographs that bear witness to beauty in everyday life.

Nevertheless, I believe that beauty is part of the information the world offers us about physical reality. It is directive information. It matters. And it is part of local knowledge. The subtle beauties of our home places are part of what gives rise to our love and cultivation of these places. The lesson I have taken from Ansel Adams is that if you love something and want to protect it, you must first point it out and argue for its value. It is not enough to show the effects of our endless human bungling and greed. I am interested in work that defines and protects the vanishing commonplace beauties that let us know that we're home. —Gregory Conniff

ROBERT DAWSON, *Indian Fishing Platforms, Deschutes River, Oregon,* 1989.

I can remember the first time I saw an Ansel Adams photograph. As a nine-year-old child, I was thrilled by his photographs of a spectacular place called Yosemite. Years later, when I finally visited Yosemite, I found the landscape disappointing compared to these first Adams images.

I grew up in California and lived for many years near Carmel. During the 1970s, I slowly became personally acquainted with Ansel. He sparked my initial interest and I learned the craft of photography by trying to imitate the technique of his photographs. Later, when I went on to graduate school I felt I had gone beyond the style of his work which in my mind was hope-lessly out of date. Nevertheless, I remained intrigued by the phenomenon of Ansel Adams.

Perhaps what impressed me the most about Ansel was his statement that he was as proud of his work for the environment as he was about his photography. That was especially appealing to me having come out of a background of activism in the 1960s. Ansel's life became far more impressive to me than his photographs. Here was a person who found a way of combining a passionate interest in landscape and environmental issues with an equal passion for photography. Equally impressive was the fact that his life seemed to retain a purpose and a sense of integrity in a society that seemed quite wacko to me at the time. Although the form of my photography, including the Water in the West Project, is different from Ansel's work, it has evolved out of a similar passion for landscape, environment and photography. We in the Water in the West Project hope that our work can "be useful" in this time of doubt. I'm sure that Ansel would feel very much the same.—Robert Dawson

TERRY EVANS, *Cheyenne Bottoms, near Great Bend, Kansas. One of the most important wetlands in the Western Hemisphere. View of a canal showing wheel that raises gate to regulate water level. August 14, 1992.*

The immensity of Ansel Adams' achievement is clear, but the landscape photography that affects me most deeply is not about monumental wilderness. It is about the vulnerability of the land, the fallibility of the people who live on it, and the enduring beauty that transcends both. I read a story once about a Plains Indian boy who longed to be the story catcher of his tribe. The story catcher filled the valued role of drawing the stories of his land and people on animal skins. These drawings were reminders to the people of what they were about. I envision landscape photographers playing this role in our communities—we photograph the stories of the land, and show how it is used and misused.

Ansel Adams inspired the preservation of wilderness. We must inspire in our local communities the preservation of our home landscapes, for they are often more endangered than wilderness
—Terry Evans

CULTURAL ARTIFACT
ANSEL ADAMS WILDERNESS

WANDA HAMMERBECK, 1992 (original in color).

My world is quite different from Ansel's. Now there is much more work to be done to make a difference in our world. One solitary heroic effort like Ansel's is simply not enough. Like Adams, my colleagues and I share concerns about the quality of life on this planet and the urgency of change. Rather than working alone, pursuing careerist goals, we collaborate and work as a team in hopes of making a difference. The stakes are high—humanity has changed the weather, the very air we breathe, the water we drink. The earth is being used up—we lose farmland and farmers and food daily. The loss of plant and animal species is staggering. No single person will emerge as the leader of the "photography pack"—the job is too big. The world senses deeply that what is needed is the contribution of large numbers of ordinary people, not heroes. Our lives and the lives of our children, our legacy, lie in the balance.

Every thing, for better or worse, is now a product of how we choose to live on the planet. Every place is an artifact of culture. We have forgotten the single most important story to tell: that humanity is a part of the biosphere. We are not separate from nature. We ARE nature. — Wanda Hammerbeck

PETER GOIN, *Abandoned hot springs near Goldfield, Nevada*, 1990 (original in color).

Ansel Adams' photographs fulfill the celebration of sublime beauty resonating in the monumental wilderness; his work marks, in many ways, the end of an era. Photography can never be the same. It is possible that a hidden legacy exists for Ansel Adams—one where his work was so very dominant that a younger generation of landscape photographers attempted to move out of his shadow by questioning, seeking, adapting and creating new ideas for representing landscape beauty.

But redefining beauty is only part of the equation. Ansel Adams' love of the land and his ardent conservationism contributed to another important yet often under-emphasized legacy: combining art and political activism. And this tradition is just now being established. —Peter Goin

MARTIN STUPICH, *View from under siphons, Columbia Basin Project, Washington,* 1991.

I probably discovered Ansel Adams in a *Life* magazine in the 50s, and in art school, I studied the Adams photographs made in the Sierra. I was impressed with their display of magnificent virtuosity; and I recall feeling embarrassment, almost guilt, at being profoundly unsatisfied by them. I had studied painting for years, so I knew that artists of great gifts amass respect, adulation, even worship. In photography, Mr. Adams was one of these. His pictures spoke eloquently to anyone not blind. I could see, but what I saw most clearly was that these impeccably made pictures revealed nothing to me of the world that I lived in.

The first photograph to really move me was made out of a hotel window in Butte, Montana by Robert Frank. That picture, in the first photo book I ever bought, marks the point where photography switched for me from Latin to the vernacular.

Frank's pictures seemed to me to be crucial to his living. Adams' seemed the opposite. They seemed to come not to him to sustain him, but *from* him, like a long monologue of brilliant diction and linguistic arabesque. These radiant black and white pictures, in their perfection, were made in heaven, or some other place I was sure never to visit. To me, Adams' work represented photography made to celebrate photography. The pictures were whole, conclusive, final—each glorious print was a complete and clear answer, but to a question I would never ask. —Martin Stupich

MARK KLETT, *Fallen cactus, new golf course, Pinnacle Peak, AZ, 7/4/84.*

I've usually felt a loss from looking at Ansel Adams' photographs, rather than inspiration. The land that I know seems less wild and full of people. Are we simply living in a drearier age, one of spent landscapes where photographers search for the last of the best places? Or are we doomed to cynicism about human abuses while photographers carry tripods into the land like hunters in search of trophies? I've not always been sure of what I wanted from my own landscape photographs, but from Ansel's work I decided that I didn't want to lament the loss of Eden.

What I like about the *Water in the West* project is that it offers an alternative to the "Master Photographer" model that has become so confining in our field. It remains to be seen whether or not a group like ours will be able to match Ansel's ability to further landscape causes, but I think the goals are in the best spirit of his concern for the land. To me that means that as photographers we participate in, and not just witness, the changes of our time. —Mark Klett

Charles Hagen

BEYOND WILDERNESS:
BETWEEN ESTHETICS AND POLITICS

It may seem a little heretical to say this here, but when I was in graduate school fifteen years ago I, like most of my fellow students, didn't take Ansel Adams very seriously. If anything, we thought of him as a bit of a joke: he was just too popular, too much of a ham. He obviously enjoyed public attention and seemed to seek out celebrity. At the time—although perhaps not today—that wasn't considered appropriate behavior for a serious artist. His pictures, too, were seen as embarrassingly sentimental and old-fashioned. To us, and to many other people in the field, Adams seemed to be the Norman Rockwell of landscape photography—extremely popular, extremely successful, but by then no longer important as an artist.

Nevertheless Adams was and is an unavoidable presence in American photography in this century. His long and varied career included his early association with pioneering Modernists like Alfred Stieglitz and Paul Strand, as well as his deep involvement in environmental causes at the end of his life. An important aspect of his work that hasn't been explored sufficiently is his mastery of photographic technique, his apparent belief that in photography, craft could be elevated almost to the status of art. For all of these reasons, he continues to exert a great deal of influence in contemporary photography.

Although many of his pictures are dramatic and striking in themselves, it is his public presence that I think is most interesting to photographers today. In his photographs Adams made effective use of essentially trite aesthetic formulas to further his political goals in relation to the land. Many photographers now look back at Adams' career in an attempt to understand what he accomplished, and how. His work represents one answer to a basic question: what kinds of pictures can best influence public land policies? And it raises in a clear form another, equally important question: do the esthetic decisions you make in your work limit, or even determine, what you can achieve with it? With these questions in mind, I'd like to step back and consider Adams' work in a larger context.

This past spring the Robert Miller Gallery in New York presented an exhibition of work by Carleton Watkins, the great 19th century American landscape photographer. Perhaps two-thirds of the pictures in the show were richly detailed, dramatic views of spectacular scenery of the West, and especially of the Yosemite Valley, of the sort for which Watkins is best known.

Included in the show, too, were a number of pictures Watkins made for mining companies in California—pictures of open-pit or placer mines, or of shanty towns erected near the mining sites. These pictures, too, were characterized by profuse detail and simple, declarative compositions, and both as formal studies and as historical records they remain interesting.

But what struck me most about this show was that Watkins apparently saw no contradiction between the two kinds of pictures, the one portraying an idyllic land untouched (and by implication unspoiled) by human presence, and the other offered proudly as evidence of the advance of industrial technology and civilization.

The split in thinking that these two types of pictures represent is at the heart of most current debates about the environment. On the one hand as a culture we value the material wealth that has been achieved by industrialization, and the growth of democracy and personal liberty that has come along with it. On the other hand we haven't figured out how to achieve these things without despoiling the land.

In the century since Watkins' time, photographers of the land have moved toward a more cautious awareness of the complexity of these questions. Adams' own attitudes toward the land changed in the course of his career, from an early interest in encouraging people to visit the wilderness, to a later belief in the importance of conservation, of setting certain wilderness areas aside safe from development. Later still he adopted an environmentalist approach, in which he was concerned with the overall relationship between human society and the land. The remarkable changes that Adams experienced in his thinking parallel similar shifts that many other people—including photographers—made in that same period.

For centuries artists were not much concerned with the land as such. Instead they were interested in the landscape, a genre of art in which the land, translated into pictures, could be used as a mirror of the artist's concerns, a familiar motif through which to present moral arguments or formal experiments.

Some artists treated the landscape as an idealized, emotionally expressive place, whether it was Claude's peaceful Arcadia, Turner's fearsome seascapes, or Cole's transcendent mountain scenes. For other artists, from Cezanne to Kandinsky to John Marin, the landscape offered a convenient subject through which to address basic questions of style and depiction. Both of these directions had little to do with the land itself as an entity outside of human definitions, but everything to do with attitudes toward it.

In recent years, though, many artists have begun to question the function and form of landscape art. In part this reevaluation is driven by the impulse of Modernist art to renew itself continually. But a more important force behind this changed understanding is the recognition that our whole relationship to nature has changed. No longer can we see Nature as a verdant limitless garden that encompasses us and all that we do.

I've just come back from Halifax, Nova Scotia, where my wife was teaching. The waters off that part of Canada have long been an extremely rich fishing ground, and much of the

culture of Newfoundland, just north of Nova Scotia, is built around fishing for northern cod. But in the past couple of years the cod have virtually disappeared. As a result the Canadian government has just imposed a two-year moratorium on cod fishing, and people are predicting the economic collapse of the province. To add to the tragedy, scientists don't know if the cod will ever come back.

People speculate that the current crisis is a result of the increased industrialization of fishing, and the appearance of fishing fleets from all over the world off Eastern Canada. But this is by no means a unique situation. Time after time in recent years we have discovered, as in this case, that nature has limits.

This represents a profound transformation in our understanding of the world. Increasingly we have had to give up traditional romantic ideas about nature's limitless bounty and to recognize the tremendous—and often catastrophic— impact human society has had on it. Among many other things this new consciousness of nature's limits is changing how photographers depict the land.

By the end of his life Adams, too, had begun to realize the limits of nature. Since his death the problems have grown even more complex, more urgent, and contemporary photographers have adopted a variety of approaches in their attempts to deal with these changed circumstances.

Two years ago I edited an issue of *Aperture* magazine entitled "Beyond Wilderness." The issue was devoted to the work of contemporary American landscape photographers. Much of the work that we looked at in assembling the issue reflected this shift in attitudes toward the land. In the end we included pictures by 30 or more photographers, including Barbara Bosworth, Richard Misrach, Robert Dawson, and Terry Evans, as well as texts by such well-known writers as Barry Lopez, J.B. Jackson, Wes Jackson, and others, in an attempt to provide an overview not only of contemporary landscape photography, but of some of the issues reflected in their work.

A number of the photographers in the issue, among them Philip Hyde and William Clift, work with updated versions of classical landscape styles. Often they pursue tactics similar to those Adams used, recording the natural beauty of the land as a way of supporting conservation programs. Other photographers make what I would call direct-action pictures, depicting specific environmental problems in an attempt to inform and arouse an audience to immediate action, to write a letter to Washington or join a protest march, to *do* something.

A third category in this brief sketch of contemporary landscape photography is composed of people who use irony in their pictures. Irony, as we all know, has become a central element in contemporary art. Addressed to an audience that is acutely aware of the long history of landscape photography, pictures of this sort record the beauties of a land that is now under attack from industrialization. But these elegiac images evoke as well the long history of landscape painting and photography. In these pictures there is a yearning not only for the wilderness as it may once have existed in this country, but also for the essentially fictive wilderness, with its pristine photographic perfection, that was created by such earlier landscape photographers as Carleton Watkins, Eadweard Muybridge, Timothy O'Sullivan— and Ansel Adams.

Today many landscape photographers want their pictures to work on several levels: to inspire awe at the beauty of the scene; to recall the history of landscape photography and

the ideals it proposed; to express outrage, and point to specific destructive practices.

One such photographer is John Pfahl, who works very consciously with ideas of the picturesque and the contradictions inherent in our assumptions about landscape photography. Over the past twenty years Pfahl, who lives in Buffalo, has taken many approaches in his efforts to depict the land in light of our changed awareness of it. In perhaps his best-known series, Pfahl photographed nuclear power plants in their surroundings. He discovered that because these plants must be located near water and away from cities, they are often placed in particularly scenic spots. Here as elsewhere Pfahl deliberately used pictorial devices borrowed from traditional landscape photography and painting in order to heighten the conflict between idealistic attitudes toward the land and the industrial uses it is put to (figure 28).

In another series Pfahl photographed the chemical clouds emitted by factories near Niagara Falls, which nineteenth- century painters and photographers regarded as the place that most clearly demonstrated the transcendent beauty of the American landscape. Pfahl's pictures, with their luscious, almost saccharine color, underscore the contradiction between the romantic beauty of these clouds, which recall the dramatic paintings of William Turner, and the chilling banality of what they are. The industrial fact of the pictures are expressed in their titles, which state in deadpan terms which factories the smoke comes from.

More recently, Pfahl photographed waterfalls, again with a sharp eye for the irony involved in the fact that we tend to value them both as sites of beauty and as potential sources of power. One of the most subversive pictures in this series, I think, is Pfahl's picture of Falling Water, the famous house that Frank Lloyd Wright erected over a waterfall in southwestern Pennsylvania. This structure has come to be regarded as a triumph of Modernist architecture, but by including it in this series Pfahl points out that it is also an imposition on the natural site. Wright treats the beauty of the waterfall as a kind of accessory to his project, and this is precisely how many people tend to regard the landscape.

In his classically elegant black-and-white prints of the Western landscape, Mark Klett seems almost painfully aware of the long tradition of Western landscape photographers (figure 29). Trained as a geologist, Klett was a member in the 1970s of the Rephotographic Survey project, in which he and several colleagues visited the sites of famous 19th century landscape photographs by Timothy O'Sullivan, William Bell, William Henry Jackson, and others. Klett and the others involved in the project photographed these sites again, both to understand better how the original photographers had worked and to see how the sites had changed.

Even now, many of Klett's pictures refer explicitly to the long tradition of landscape photography, in both their subjects and

Figure 28 JOHN PFAHL, *Rancho Seco Nuclear Plant, Sacramento County, California*, 1983 (original in color).

Figure 29 MARK KLETT, *Under the dark cloth, Monument Valley 5/27/89.*

titles. Among other things, Klett has photographed Native American pictographs, saguaro cactuses that have been shot up for target practice, and his own campsites. In these and similar pictures he tries to uncover the layers of significance in both the reality of the American landscape, and the meanings we have imposed on it.

Other photographers use ironic devices to underscore just how loaded with preconceived meanings most landscape pictures are. In a recent exhibition at the Ansel Adams Center, Vikky Alexander and Ellen Brooks presented photographs of landscapes, many from garden and home magazines. These had been re-photographed through a black plastic mesh that obscured the image and made it more generic, while also evoking the grid pattern of halftone screens. "Windows" had been cut into this overlay to reveal the magazine photograph beneath, seemingly to offer an unrestricted view of the scene itself. But as the works made clear, the magazine photographs themselves were simply trite restatements of pictorial clichés about the land (figure 30).

In his photographs of the Nevada desert Anthony Hernandez depicted places where people go for target practice, shooting bottles, cans of paint, dolls, and other items. Hernandez photographed the fields of broken glass and spattered paint he found there from close up, producing richly colored pictures that recall certain forms of abstract painting. In another series, called "Landscapes for the Homeless," Hernandez photographed the places in Los Angeles where homeless people live—in parks, under the freeways—emphasizing the formal qualities of the pictures. These pictures also set up an ironic contrast between the tradition of landscape photography and the horrific social realities faced by the homeless (figure 31).

In the end, our attitudes toward the land are as important in shaping it as are forest fires,

Figure 30 VIKKY ALEXANDER and ELLEN BROOKS, *American Landscape Series, Northern California Coast* (original in color).

Figure 31 ANTHONY HERNANDEZ, *Landscape for the Homeless, #2,* 1988 (original in color).

earthquakes, or erosion. And photographs of the land play an important part in determining and reflecting those attitudes. For many people, questions about how best to depict the land have taken on an almost theological tone, involving as they do the much larger question of our relationship to the rest of creation. So long as we persist in seeing ourselves as being outside nature we run the risk of continuing to treat it as either a tool or an enemy, something to control or conquer.

Bemoaning the end of nature, as some writers have done recently, does not seem particularly fruitful in thinking about our responsibilities toward the land. At the same time, to jettison a century's worth of environmental awareness for the sake of a vaguely defined economic "competitiveness," as former Vice President Dan Quayle wanted to do, would be simply stupid.

Instead, I think contemporary landscape photography needs to reflect an awareness of the full complexities of these questions, and a recognition of our deeply symbiotic relationship with the land. As part of this we must recognize that 42nd Street in New York and the San Diego Freeway are part of nature, and part of the landscape, and have to be considered as carefully as does Yosemite National Park. If we persist in defining nature as something outside of ourselves, as wilderness, then we fail to address the real source of our current problems.

In his many letters Ansel Adams seldom expressed his feelings towards his pictures and the land. Adams' reticence helps to clarify something I've always noticed about his photographs, that in making them he is always outside nature, looking in. No doubt this says something about Adams himself, but I think it also reflects the contradictory attitudes that we as a culture have toward nature. It is time to break free of those contradictions, and to begin to find other, more appropriate ways to understand the world and our position in it. Landscape photographs provide a good place to start that difficult and essential process.

Picture Credits

THE FRIENDS OF PHOTOGRAPHY, founded in 1967 in Carmel, California, is a not-for-profit membership organization that operates the Ansel Adams Center in San Francisco. The programs of The Friends in publications, exhibitions, education and awards to photographers are guided by a commitment to photography as a fine art and to the discussion of photography through critical inquiry. The publications of The Friends and the exhibitions at the Ansel Adams Center are the primary benefits of membership; they emphasize current photographic practice as well as criticism and the history of the medium. Membership is open to everyone. To receive additional information and a membership brochure, please write the Membership Director, The Friends of Photography, Ansel Adams Center, 250 Fourth Street, San Francisco, California, 94103.

This is the fifty-fifth in a series of publications on photography by The Friends of Photography. Previous issues are still available. For a list of these titles, write to: Publication Sales, The Friends of Photography, Ansel Adams Center, 250 Fourth Street, San Francisco, California 94103.

CONTRIBUTORS

David Featherstone is an independent curator, writer and editor based in San Francisco. He served on the staff of The Friends of Photography from 1977 to 1991. He has recently been involved in a variety of exhibition and publishing projects.

Charles Hagen, formerly an editor of *Aperture* and *Art Forum* magazines, currently writes art criticism for the *New York Times.*

Renée Haip is an independent photographer and writer living in Lyons, Colorado. She worked at the Center for Creative Photography while obtaining a B.F.A. in Photography and an M.L.A. in Landscape Resources at the University of Arizona.

Sandra Phillips is currently the Curator of Photography at the San Francisco Museum of Modern Art.

John Pultz is completing his dissertation on Harry Callahan at the Institute of Fine Arts at New York University.

Robert Silberman is currently an Associate Professor of Art History and the Director of Film Studies at the University of Minnesota.

Colin Westerbeck is Assistant Curator of Photography at the Art Institute of Chicago.

Water in the West Project members

Gregory Conniff is currently photographing reservoirs and water systems in North and South Dakota and, in collaboration with Terry Evans, the Cheyenne Bottoms wetlands in Kansas.

Robert Dawson, Co-Director of the Water in the West Project, is currently working with writer Gray Bechin on a book and exhibition entitled *Farewell Promised Land,* and photographing along the Truckee River and at Pyramid Lake in collaboration with Peter Goin.

Terry Evans is currently making aerial photographs documenting the relationship of sustainable agriculture, agribusiness, archaeological sites and the military to the native prairie of the Great Plains.

Peter Goin is currently photographing the effects of the nuclear industry on the western landscape and documenting the struggle for water rights between the Paiute Indians of Pyramid Lake and urban development in Reno, Nevada.

Wanda Hammerbeck is currently investigating the individual's relationship to nature and landscape through large-scale color photographs with text. She is also conducting an extensive photographic survey of daily life along the concrete channel of the Los Angeles River.

Mark Klett is currently photographing the lower Colorado river basin, and the impact of development on the landscape and culture of the Southwest. He recently initiated "Water as Cultural Reflection," an interdisciplinary project that will study both historic and contemporary perspectives on water in the Phoenix area.

Ellen Manchester, Co-Director of the Water in the West Project, is a photo historian, curator and arts administrator. She was a founder and Director of the Rephotographic Survey Project and has been a member of the Board of Directors of Earth Island Institute since 1981.

Martin Stupich is currently photographing dams, bridges and other large-scale public works throughout the West for the Historic American Buildings Survey, the Historic American Engineering Record, and the U.S. Department of the Interior.